Monet

Vasile Nicolescu

ABBEY LIBRARY
LONDON

o n e t

Translated from Romanian as published by
MERIDIANE PUBLISHING HOUSE
Bucharest, 1976
under the original title of
MONET
by
VASILE NICOLESCU

Translated into English by
ANDREEA GHEORGHIŢOIU

A poet of the *state* of light, of the flow of life and of the floral cosmos, Monet was a great contemplative, one of the purest that European artistic sensitiveness has ever produced. The condition of the world is the condition of the human being caught in his primordial and innocent grappling with the elements, a tense grappling experienced through intuition and dreaming, in a non-aggressive way. What — with Turner — was drama proper, inner excruciating and harrowing, and, as a compensation, a visionary searching and liberating frame of mind, turned — with Monet the Impressionist — into a dynamically contemplative attitude, the will to structure through unstructuring, to express the real as the hidden power of the essential. The dramatic liberation — at any cost — of light from colour, which was the last and deepest obsession with Turner, the real founder of Impressionism — an obsession no doubt, yet one of the first victories scored by 19th-century painting — became, with Monet, a means of building up the world, of creating it in the light of a new ideal. Turner's terrible scenography is replaced by life itself, life with contours changing imperceptibly, pulsating with the thirst for permanent birth and rebirth. Light is no longer "damnation" [1], a real "Last Judgement" of the spirit, overwhelming like a whirling, raging storm. With Monet light becomes the magic garb that makes the flesh of things transparent, the *sign* conducive to the simultaneous grasping of their genesis and death, the bridge from which we cast a sweeping glance at the worlds, the stars, the void, the flickering of constellations unborn and the seemingly blue chasm that separates us from them. For the painter of the *Poplars, Haystacks, Cathedrals* and *Waterlilies*, light is the symbol of the spiritual warmth of everything surrounding us, the psychology of elements the way we see, perceive and experience it when living our own life. Monet grasps the dialectic mobility of things, their Heraclitean flow, in a word, he grasps the phenomena of life with the ingenuousness of a poet-painter. A dialectics of appearances or of depths, Claude Monet's painting reveals a simple, moving truth: all through his life the painter possessed a fine sense of continuity, actuated by his faith in the pure commandment of light, which enabled him to confess, the same as Gaston Bachelard: "Burning all the time, the flame must burn brighter, maintaining the commandment of its light over gross matter. If our sense of hearing were keener we could hear the echoes of its most intimate agitations." [2] The flickering of the "poppies" — the rural apotheosis of vegetal fire — of the "gladioli", the mysterious flickering of the "wistaria" or of the "waterlilies" in *Yellow Nirvana*, of the fluttering banners in the grand festive canvas *Montorgueil Street Decked out with Flags* or of the *Haystacks* — resembling the points of cones and suggesting the unreal presence of some meteors — are "echoes" of the agitation of inner flames, of an inner combustion which will cease only with the artist's death. No matter the gains of his innovating technique (the function of the divided, transparent touch, framing etc.), what was indeed fundamental with the artist and a peculiar feature of his personality and even of his style, was his acoustic ability to sense, through colour, the things consuming themselves in search of new forms, the molecules of air struggling as the molecules of light vibrate. The fleeting impression reflects the deep essential character of reality: its unceasing movement and our desire to perceive it, to grasp it reflexively.

Mindful more than one might believe of the lesson of his forerunners — Courbet Delacroix and Corot first —, responsive owing to his structural affinity to the English landscapists Constable and Turner (the latter more especially), — Monet was a *total*

[1] D a n H ă u l i c ă, *Turner*, "Secolul 20", No. 4, 1974
[2] B a c h e l a r d, *Colloque de Cerisy*, Union Générale d'Editions, 1974

painter in the first place, even if he is considered a classic of Impressionism; for, owing to his keen and complex feeling and the unassuming and unobtrusive incorporation of the real, he transcends his own formula that made of him the head of a school. It is quite significant that after the effusions and rhetoric of Romanticism, at a time when Baudelaire's austere aesthetic catechism was gaining ground (in fact a Platonic reverberation of the contemplation of absolute beauty, which his line: "*Je hais le mouvement qui déplace les lignes*" expressed) at a time when Lecomte de Lisle, Téophile Gautier or José María de Heredia were seeking a source of inspiration in mythology and polished their crystal-clear verse improperly called Parnassian, Monet and together with him a whole constellation of painters were trying to express *movement* itself either as an endless flow of life or by grasping the dramatic ephemeral aspect of things. It is all the more important to emphasize the fact that unlike the bookish imagery of the English Pre-Raphaelites — a movement taking inspiration from the programme of the Neo-Romantic Ruskin as a reaction against the onslaught of industrial civilisation and the Positivism of a thinking which excluded the authority of dreams and of contemplation — the reaction of the Impressionist painters, Monet's in the first place, did not spring from the transformation of precepts or ideas into canons but from a new attitude to reality which they got to know kaleidoscopically in its endless variety of nuances.

On a general plane this may require even a change in our way — limited sensorially — of perceiving and recording movement as a successive presentation of the real like a mechanical progress, whose successive moments are comparatively stable. Accustomed as we are to an image of reality in which the aspects of the rigid substance of forms and precise dimensions prevail, it is rather difficult for us to grasp concomitantly their "flow", their endless movement.

Any sensitive and careful observer will realize how easily discernible are the changes occurring in objects, in their visible contours, in their external features, under the influence of light, of the air, of all the diffuse phenomena of the atmosphere. It is natural for us to perceive an object as quite identical with itself, although — objectively— our representation of it changes with every moment, owing to the many details we no longer notice. The intuition, the technical devices of the Impressionists confirm this truth. This goes to explain perhaps why Monet's painting has been interpreted as the expression of the deepest realism; and quite rightly so. The keen eye of the painter, trained to discern the shades of colour and light, can see that a particular aspect of the same *Rouen Cathedral* is not only a reflection of the artist's creative personality but the result of a precise, meticulous transcription of some details, of reality as well which the senses can identify. Bearing all this in mind, Impressionism can be grasped in its complex relationships with tradition, which can be explained not only through discontinuity but also through continuity, through creative dialectical negation. Thus Impressionism is no longer a mere formal experiment — as it was considered sometimes— but a fruitful renewing aesthetic conception, of great help in the investigation of reality and of human sensitiveness.

Impressionism, whose name was coined in jest by the journalist Leroy in "Charivari" having seen Monet's painting *Impression, soleil levant*, is therefore a variant of realism (Zola used to call it *Naturalism*), an open flexible variant. It was a new revolutionary formula consisting in an utterly unbiased attitude to the more or less resisting techniques and mechanisms of Academic painting as well as in the effort to "detheatricalize" painting, to simplify the "mise-en-scène" and the conforming fatally abstract formalism which needlessly tried to animate the characters. The last though not the least important feature of Impressionism according to Léon Degand — one of the authorities on the phenomenon — is *pleinairism*, on condition that the work should be completed in the atelier. The verticality of Courbet's Realism daringly opposes, in point of composition and character, the infinite horizontality of Impressionism, the space of virginal colours, of uninterrupted metaphors, the diffuse chromaticism which creates the calm harmonies of life. Monet, the earliest and also the last Impressionist, a witness of Neo-Impressionism, Expressionism and Cubism, was to serve and preserve the same creed, the same sincere attitude to Man and Nature to the last touch of paint laid on the sidereal petals of the *Nymphéas* (Waterlilies) in the *Orangerie*. The most *lyrical* of Impressionists, Claude Monet, commands respect through his fruitful and consistent attitude to his art, to its finality and aesthetic effect. To the musical rigour of Manet's line, the crepuscular or matinal solidity of Renoir's nude, the soaring flight of Degas'

ballerinas and the majestic simple rhythms and architecture of Cézanne, Monet adds the basically lyrical condition of the relationship between Man and Nature. This is an existential, aesthetic attitude which his *whole* work illustrates.

Trying his hand at caricature — with a talent that roused general admiration — the young man who roamed the beaches at Le Havre was to paint, under the indisputable influence of Boudin, seascapes in a freely naïve manner by which he wanted to train his eye and hand and forced upon himself a contemplative style. He made a lot of experiments; in fact he was to do so to the end of his life. It is only with a courage hard to assess today, considering the stir it created at the time, that Monet painted his own *Déjeuner sur l'herbe*, a very personal version of the already famous (though condemned by officialdom) *Déjeuner* by Edouard Manet. Assimilating as much as his temperament allowed him of the petty metaphysics in the famous Parisian cafés of the time (Café des Martyrs, Guerbois, etc.), alternating spectacular success with unimaginable moral disasters — proof of it his attempt upon his own life on account of destitution — Monet listened, above all, to the inner voices of his sensitiveness. He compared his works with those on show in all the painting *salons* of the time. He travelled extensively. He made friends, with adolescent tenderness, with the great contemporary painters, some already famous, others on their way to fame. During the Franco-Prussian war he was obliged to leave his family and take refuge in London, experiencing the deep emotion created by the apprehension of Courbet, the closest to him of his masters, who had participated in the revolutionary activities of the Paris Commune. Claude Monet was moved by Zola's "J'accuse" which came like a thunderbolt; he was a contemporary of the first photos, of the rather carnivalesque décor of the so-called "La Belle époque"; he listened to Rostand's tirades, he understood the synaesthesias the Symbolists' aesthetics suggested; he felt the echoes of Verlaine's "*romances sans paroles*", the nostalgia that took Gauguin to Tahiti and the bitter turmoil that made Rimbaud experience *Une Saison en Enfer* and, he sensed the tumult in Wagner's *Parsifal*. He also came to know the sonorous alchemy of Mallarmé's lines which helped Debussy create the dim sensuous frenzy in *L'Après-Midi d'un Faune*, he was moved by Huysmans' novelistic attempts as well as by the charm and almost ocult science with which the author of the *Blue Bird* spoke about the *Intelligence of Flowers*...

Camille and *Portrait of M^{me} Gaudibert* reveal the psychological insight of a brilliant painter; he also greatly surprises his contemporaries with three views of Paris "taken" from the roof of the Louvre, in which the Impressionist technique gives way — bafflingly enough — to a precision which is closer to a fine photograph than to painting proper. He reaches perfection in this manner of painting with the exact reproduction of the Saint-Germain-L'Auxerrois cathedral. On the other hand the fairy-like atmosphere of the whole, the ever subtler alternation of light and shade in Monet's picture *Women in the Garden* executed in the same year and representing more than an inner age of his painting, illustrates the most lasting feature of the painter, his absolute inclination for *impression*. The predilection for clear tones combined or superimposed — after the happy experiments with the *Sailboats* at Argenteuil — becomes prevalent in the *Poppies* where "the green fields offer a spontaneous example of dissociated hues and of contrasting complementary colours; the thickened texture seems to make the growth of the flowers perceptible, painted bigger than they really are." (Jean Leymarie).

The same Jean Leymarie was to say that this canvas "marks the happy transition from the clear and sincere manner of painting he had adopted in Holland in 1862, still indebted to Jongkind and Daubigny, to the new vibrant and colourful manner peculiar to Impressionism."

It is apparently curious that the painter most absorbed in nature, in its fleeting or lasting elements, — proof of it are the great periods that ring deep in his work (Argenteuil 1878—1878; Vétheuil 1878—1821; Giverny 1883—1926) — never ignored the field of observation the town offered him, its vitality, its milling frenzied crowds. Monet made Impressionist masterpieces for which the townscape was his source of inspiration. Townscapes with exuberant people during carnival time, *Boulevard des Capucines* (in which houses, trees and people recall the extatic density of some canvases by Brueghel) or the series of canvases for which he took his inspiration from Saint-Lazare Station, are no mere pretexts to analyse light effects and its variations. Monet wants to render life, from the most unusual aspects of civilisation to the most secret recesses of nature. The choking, oppressive atmosphere of the tarred and smoky Saint-Lazare Station,

the *Railway Bridge at Argenteuil* or the landscape caught between metal bars with a few human shapes in it in *Workers Unloading Coal*, illustrate his complex sensitiveness, the fact that his vision is akin to the tense, dramatic aspects of life. In this respect we should venture the opinion that the themes proper were not so unimportant to him as some of his exegetes are trying to demonstrate. Nevertheless, the painter can always catch the life of the elements, the dulled terror of nature, as well as the "Thaw" for instance, "a substantial nothingness" as Gaston Bachelard describes it, using a splendid image.

In his conception, the water is not only matter or an element of despair. The colour of granite, or intense like some minerals, of an iridescent green, as troubled and convulsive as fire, the water gradually assimilates the attributes of the whole, to become the universal background for all the painter's gestures and for those of nature. Claude Monet cultivates a genuine poetics of the water.

"The Clouds", writes Sabine Cote [1], "are made of the same material as the waves. This foamy existence, this surf of matter spreads all over the canvas which seems to be rippling to the rhythm of the brush strikes, of the eye and of the hand. It is quite certain that in this case a particular matter outstrips all the others, added to its own organic pulsations."

A Raphael of the sea, as he was called, a poet of the air, the clouds and the vegetal universe, Monet expresses himself with deep smiling joy. Controlling his own reverie, he does not purport to unravel enigmas. The lucid trance of the painter springs from an ideal of construction he expresses sincerely and vividly thanks to his dignified complete participation. An art "of the retina", of the simple "fleeting impression", as impressionism was superficially termed, Impressionism generally and Monet's Impressionism more particularly recompose the world with wonder and an unconcealed praise of beauty. "Seldom before the period of Impressionism was painting instinct with such fresh, unadulterated lyricism," Tudor Vianu wrote in one of his inspired early essays. [2] "To advance candidly in the midst of nature, to marvel at the whitish blue sky, at the light trembling over the stones, at the gold melted in each drop of air and in the vastness of the whole space — isn't that the purest form of lyricism? Sensations never enter our conscience cold and informative; they pervade our body, they accompany its energy and langour, they adopt some of its dreaming and revolt, and in this very moment — which for a limited conscience, unable to take the impression to the depths of our soul, remains a cold informative sensation — the body pours forth the hot lava of voluptuousness, melancholy and aspirations." This description suits Monet to perfection more than it does any other Impressionist. The lyricism in Monet's painting is the lyricism of experiencing, of participation, of construction, and it is also the lyricism of mystery which is enhanced by light. The quivering light that pervades Monet's canvases becomes an impulse to grasp what is alusive, to grasp the non-finite. Such an intention seems to have created the well-known line by poet Lucian Blaga:

"I with my light enhance the mystery of the world."

Mystery is not a mark of the labyrinth, of the enigma. Mystery is something that transcends the usual, the distance between objects, the invisible upon which the visible — directly communicating — is based. So what are in fact Monet's *Poplars* painted by him after the great experience of Divisionism, of chromatic transparencies, turned to good account in purely Impressionist canvases such as the landscape paintings of Bordighera, Etretat (with the Cyclopean *La manne porte, Etretat)*, Éstaque, Belle-Ile, Antibes, London, Fresselines — the quivering silhouettes in the series he started working on as well as the no less valuable *Haystacks* of about 1890? What are those *"vivants piliers"* but symbolic signs of the fusion between sky and earth, capitals — at the top — which support the blue everlastingness or, seen from the base reflected by the water, roots of life itself? The universe, reconstructed according to the simple laws of the candid amazed eye becomes, under Monet's brush, a temple whose columns seem to be the pipes of a celestial organ, ringing with the voices of all the spirits of life, of cosmic matter. The novelty of the *Poplars*, Rouart tells us, resides in the "ornamental linear stylisation, associated with the moving undulations of light, which reaches a refinement and purity which are almost abstract. The subtlest variations of hues follow in their movement the network of light rectangles which form — in the sky and in the water — the elaborate

[1] *Monet*, Editions Henri Scréspel, Paris, 1974
[2] *Modern Fragments*, Cultura Naţională, Bucharest 1929

and sensitive geometry of this painting. With the series of *Haystacks* the painter experiences the dilemma expressed by the need of immediacy required by the need to surprise the object in a favourable moment of light, and by the spontaneous "inspired" movement of the brush on the canvas. His technique in the treatment of light reaches perfection. What is striking indeed for all those who study Monet's painting is the symphonic-pictorial structure of his series of Rouen Cathedral, which points to the great impact of William Turner on the French painter, even though he denies it. Yet, this influence was well assimilated by a man who had a genius for construction. The architect of the slender columns his "poplars" are, is now building cathedrals similar to some floating mountains or ghostly crenellated rocks hiding behind clouds which let the light of dawn pass, smiling in all the hues of the rose; and then, you feel rising thousands of golden iridescent threads like as many trumpets, as thin as light, intoning the all-powerful hymns of the sun. At other moments of the day, when the sun starts descending slowly towards other climes and the infinite seems to be vaguely enveloping the towers and portals in a blue haze, one can hear the cry of Mallarmé, the most silent of poets:

"Il roule par la brume, ancien et traverse
Ta native agonie ainsi qu'un glaive sûr;
Où fuir dans la révolte inutile et perverse?
Je suis hanté. L'Azur! L'Azur! L'Azur! L'Azur!"

The *Cathedrals* display Monet's consummate technical skill, as also lyrical depths which the poetry of the time seldom reached and, if so, with great difficulty too. The same as Turner formerly, Monet expresses here, owing to his deep feelings, something that was termed *visionary impression* in its purest form. Unreal at first sight, *The Cathedrals* strike one through their elemental, threatening massiveness. They are impersonations of a dense, tough matter which suddenly changes under our very eyes into flashing presences, phantasms of the absolute. This play of appearances, this subtle choreography of the aspects of light make us believe that, no matter the limitations and avatars of Impressionism, the "cathedrals" — and not only them — are lasting, undeniable assets of great art and can be placed — without any Academic modesty — side by side with *Las Meninas* by Velázquez, *Olympia* by Manet or *Starry Night* by Van Gogh. The depth of his work roused the boundless admiration of a Cézanne, Degas, Renoir or Sisley.

However, Monet's highest achievement was *The Sistine of Impressionism*, the series with numberless variants of the *Waterlilies*, displaying his daring imagination from the first to the last sketches. They are "much more daring", Malraux says, than the murals he did in the Musée de l'Orangerie. A great observer of nature, feeling deep inside its drama and splendour, Monet never decorates, he never ornates. The nineteen panels making up the almost unbelievable floral suite represent, in a sublimated way, the inextricable fusion of the fundamental elements. Informal abstraction? The painter has his last dialogue with the movement and rhythm of lights, a dialogue in which his sensitiveness arranges questions and answers in musical order. The painter "symphonizes" colour, attentive more than ever to the harmony of the whole.

Did he ever "watch", like the Flemish symbolist Maeterlinck, the tragical marriage of the hydrocharitaceae, the subtle eroticism of the orchids, described in *The Intelligence of Flowers?* Or did he dream, as Bachelard suggested, the "dialectic dream" of the waterlily and the waters of the sleeping pond? The waterlily is an immaculate synthesis of nature and, in his vision, it acquires an almost emblematic symbol. The transfigured figurative nature of the "waterlilies" created in us the vision of an extremely beautiful world. Matter, the matter of the petals sings in all the tones of light. The most consistent of Impressionists becomes a moving lyrical Realist: the floral cosmos of Giverny, the "panels" in the Oval Hall of the Orangerie asserts the infinite of the dream and also man's unquenchable power of creating beauty. Ill with cataract, his eyes diseased maybe on account of the blinding light of his floral constellations, blind in the end, I believe that the painter heard the symphonic modulations of the waterlilies, the speechless ode of joy, the last ecstasy — a strange and privileged compensation for his sufferings.

ANTHOLOGY OF TEXTS

*I should always like to be in front of the sea or at
sea and when I die I wish to be buried under a buoy.*

MONET

Impressionism, which contributed so much to freeing art from the rule
of a wrongly understood tradition, can hold a place today among the great traditions.
Like any tradition, it will be denied at times, only to be rediscovered later; sometimes
it will be abandoned, other times it will become a vital factor for new quests. It will
be admired or fought, but it will never be ignored.

Impressionism will always be one of the important stages in the history of
modern art. . .

The achievements of Impressionism had become a common heritage and the
starting point for new conquests. It is a fact that the young people had come to reject
most of the Impressionist principles, that the Fauvists, the Cubists, the Expressionists,
the Futurists, the Dadaists and the Surrealists had opened up, each in turn, entirely
new horizons. Their quests, however, had been supported by the works of Cézanne,
Gauguin, Van Gogh and Seurat who had all passed through an Impressionist period.
Though the direct influence of Impressionism on contemporary art can seem to be
negligible sometimes, though it was only Bonnard who — of the 20th-century
painters — was to develop his own style in a genuinely Impressionist spirit, Monet's
as well as his friends' art was the first to do away with countless preconceived ideas
facilitating new daring attempts in point of technique, colour and degree of abstractisation.

ELIE FAURE

"I paint as a bird sings", he wrote once to Geoffroy, and these clear, simple
words reveal the natural spontaneity of Monet's creative endeavours and the irrepressible
impulse which made him use that image; these words ring with the joy of his poetic
voice, free and all-embracing, a pure song he was able to hear only after painstaking
searchings. All along his activity that covered more than sixty years, the painter was
faithful to his sure, formidable instinct, to his temperament which, mindless of hesitations
and perplexity, led him to one single concrete problem. . . *squisitamente pittorico*, to light.
It was not an abstract, emblematic light, a magic metaphysical presence, but a true light
which. . . spread in infinite variations over all objects to reveal their existential flow:
light as an instrument to make the contingent revealing, an infallible probe sounding
the moving world of appearances, a dimension of the new poetics of the *hic et nunc* which
he discovered by intuition in the sphere of figurative art.

ALBERTO MARTINI

It is not necessary to force reality in any way in order to claim for Monet the place
of a great discoverer, of a great initiator and to make him emerge from the quasi-solitude
in which hazard keeps him locked up today.

RAYMOND COGNIAT

Would Impressionism have existed without Monet? Probably it would, for
the great artistic movements appear independent of individuals, recorded in the great
book of human events, with the force of a prophesying genius; the same as in human
events, there is something biological in such movements. Nevertheless, Monet hastened
the advent of this new school which was to steep international academism into oblivion
and disapproval. With a prodigious talent which enabled him to distinguish the quiver
of the multicoloured epidermis whenever he examined the inert structure of objects,
he galvanized through his example a number of well-known painters and the consequences
of this revolution are incalculable to this day. Before him, the visible world was firmly
set in an almost immutable frame and everything that happened on the stage of this
theatre seemed to be cast once and for ever in lasting formulas. The Italian perspective

had solved the problem of space, while the problem of light was solved by the play of shaded off tints, the brightest light was rendered by the lightest tones and shadow by the most opaque ones. *Thus drawing solved everything*, as colour had nothing else to do than pour over the *absolute tones*, like rain over the pebbles it embellishes.

Monet was the first to change all this: light was no longer the lightest tone but the warmest, while shadow became the coldest *(warm* was any tone containing or seeming to contain orange, while *cold,* blue)!

The iris poured its treasures over all forms; the word *painting* acquired a purer sense and, at the same time, the word *drawing* lost the meaning of sculptural quality to acquire a different one and become an *element of distribution*, which did not lessen its importance, on the contrary. Instead of being laid *over* the forms, colour was introduced inside them and it was to stay inside them for ever.

ANDRÉ LHOTE

Monet is nothing but eyes, but Lord, what eyes!

CÉZANNE

When thinking of him we should not say "What eyes!" quoting Cézanne's famous *bon mot;* on the contrary we should say: "What a memory!"

Far from being mere passivity, Monet's immediacy implies an extraordinary generalizing power, a power of abstraction.

MICHEL BUTOR

Monet was, no doubt, an inventive genius of the vision; he was able to perceive in the relation of light and colour something that nobody before had seen. Concentrating on light and colours he discovered the form that suited best the values of light and colour, enhancing them, extracting them from the other elements of painting.

Moreover, as he was painting with the definite purpose of representing what is termed light-colour, Monet spontaneously and almost unwittingly excluded any external element. . .

Monet's eye was therefore the eye of a genius, inventive, exceptional.

LIONELLO VENTURI

The wonderful method that Monet devised, foreshadowed by Constable, was to let the onlooker's eye combine the tones and participate in the fusion of the atoms in this floral overflow. "All the molecules of the painting possess an irradiating force, they live and vibrate." Endless exchanges occur between substances, freed of their usual attributes: water gives light like a fire. The opaque matter becomes transparent, the solid one just vapour. Everything that seemed correct, normal and sound seems to be contradicted. To be able to understand the shock any usual onlooker felt in the presence of canvases which, at the time, were considered to offend human dignity, common sense and art, we must quote the articles published about 1875. But what, to me, is more extraordinary, is the inflexible logic, the stubborn fight—fraught with the risk of dying — put up by the Norman explorer for what he believed to be the truth, against poverty, lack of understanding.

CLAUDE ROGER-MARX

Sisley did not go as far as sensation, he stopped at sensitiveness like an architect who, with utmost skill, carries a traditional structure to the limits of its resistance and succeeds in making it create new effects. Leaving aside feeling and sensitiveness, Monet contributed a structure which, besides being more powerful, more elastic, was altogether new. It is a qualitative leap, like that of builders who, using iron instead of stone, create a space which is wholly and structurally different.

GIULIO CARLO ARGAN

Boats at Argenteuil is even more fantastic. Monet feels the need to rigorously close the space in order to raise to the skies those luminous filaments, the masts of the sailing boats and their reflection in the water; they are not simple fireworks for they are too pure, too intimate, the very voices of the soul. . . They are Monet's moments of grace, the legends of his colour, the contemplation of the wonderful thing the world is.

LIONELLO VENTURI

Never before Monet had anybody had the idea of grounding the whole representation of the world on the decomposition of light into pure hues. The presence of adjacent elements and of purely formal analogies never allows the identification of structure. On the other hand, whenever an artist, today, endeavours to wholly retain the first and coloured sensation, the vision of a motif caught instantaneously in a particular light, he carries further the experiment of the impressionists. At times it is a detail of the execution inserted in a differently structured work, at other times, on the contrary, it is a first orientation which other signs materialize. It is a fact, at least, that a great change occurred from Manet to Monet: the same as Courbet, Manet was bound to the obvious existence of the object while Monet replaced the object by the motif detached from the contents of the vision at the level of sense perception; yet he does not do it by any reference to the operational experiment. Besides, Monet replaces the local tone by the atmosphere, renewing Manet's project and adding to it, however, the notion of the decomposition and synthesis of the luminous perception at the level of conscience. There is in it a double transfer which, in the last analysis, no longer occurs in the external world but in the spirit of the artist and of the onlooker.

PIERRE FRANCASTEL

Monet, like Hylas, was to die leaning over the pond, caught in the vortex of this liquid surface — and the earth, the trees, the sky will no longer have their own existence: they will be nothing but delicate reflexes drowned in the water, absorbed in it, taking shape in its quivering, undulating forms.

RENÉ HUYGHE

Confident in the freshly discovered formulas of the Japanese prints, he juxtaposed the *à-plats* of colour in order to express a particular quality of light and atmosphere and, at the same time, to define the peculiar features of the subject. To produce the desired effect, Monet shows his confidence in the various oppositions between the graduation and the contrast of colours.

Thus he becomes separated from the contemporary works by Manet who turns towards tonality and lays stress on the contrasts between the texture of the painting and the value of colours.

KERMIT CHAMPA

It is quite clear that he does not choose a subject or a point of view at random, and that dwelling on an object the pictorial solution already took shape in his imagination.

WILLIAM SEITZ

When we look at the work of Claude Monet or Paul Cézanne, we can see that in the latter 19th. century colour conveying some atmospheric mood of nature, or colour expressing form, was a factor of growing importance, and that the interest of objects or figures depicted was only secondary. Thus, when Monet paints the porch of Rouen Cathedral he is little concerned with Gothic architecture, but gives us instead a sort of colour poem.

WILLIAM GAUNT

In the series *Poplars on the Epte* (1891) Monet turns from the curved forms of the haystacks to verticals treated almost geometrically. . .

One critic said that the series represented "a cosmic pantheism, giving the sense of duration, even of eternity..."

PHOEBE POOL

The full development of Monet's broken-colour technique is even more clearly discernible in the *Garden at Giverny*. . . In it he breaks his light up into a spectrum of bright colours that delights the eye by forming shimmering patterns in and around the leaves and lilies. Water imagery repeatedly recur in Impressionistic painting. Its iridescence, its fluidity, its surface reflections, the perpetual play of changing light, make it an ideal medium for conveying the conception of the insubstantial, impermanent fleeting nature of visual experience. This is but one of many versions Monet painted of the same subject. It was his habit to do the same subject over and over again, and it is evident that subject

matter was of little concern to him. With scientific detachment he tries to maintain the constancy of his subject matter so as to focus the interest on the variable of light and atmosphere. Each version varies according to the season, day or hour.

WILLIAM FLEMING

Remember the names of Renoir and Monet, the two real masters of the school which, instead of being in favour of art for art's sake, are in favour of nature for nature's sake.

ARSÈNE HOUSSAYE

Painters of nature, of the "*plein-air*" impression, Monet more especially and Sisley too will feel the urge to subject form to this coloured impression, i.e. to melt it in the sensuous exhaltation of colour.

The attachment to the direct sensation, which is the main common feature of impressionists, the rendering of the changing light and of the landscapes bathed in sunshine, will eliminate earthen colours and black from the palette, in favour of the brightest hues; all this had already tempted Turner, Delacroix and Courbet and had been achieved more daringly by Bazille. Finally, in order to render the solar effect, they used a free manner of painting in which the touches of colour are not mixed but juxtaposed; this technique has the merit of preserving the integrity of the tone, and lends to the painting a tremulous appearance helping to express the vibrations of light which the painters try to recreate. As the hand moves slower than the eye — which can suddenly catch the intensity of the phenomenon — one must discover a permanent pictorial phenomenon, starting from a rapid execution able to express simultaneously the multiplicity and rapidity of perceptions.

PIERRE CABANNE

Monet, unique, owing to his sensitive retina, an exceptional analyst of light and master of the spectrum...

PAUL VALÉRY

The method of suggesting through incomplete patches became generalized and was the only means of rendering forms. The active participation of the onlooker, his effort to recompose became essential. It was Monet's great lesson to have taught us to recompose a painting the way we recompose a landscape we contemplate in the midst of nature.

PIERRE FRANCASTEL

What distinguishes Mr. Claude Monet's talent from any other is his magnificent and erudite simplicity; his implacable harmony. He expressed everything, even the imperceptible, even the ineffable, to put it briefly, the movement of unseen motionless things such as the life of the meteorites; and nothing is left to some chance inspiration, even if happy, to some fanciful stroke of the brush, even if it is that of a genius. Everything is well ordered, everything is in full accord with the laws of atmosphere, with the precise, regular course of earthly or heavenly phenomena. That is why he gives the complete illusion of life. Life sings in its quivering distances, flourishes, fragrant with its garlands, shines bright in the hot whirling sunbeams, envelops itself in the secret blurring mists, grows sad at the sight of the wild bare cliffs, consumed, wrinkled, like the faces of old people. He grasps the great dramas of nature and renders them in the most suggestive way.

OCTAVE MIRBEAU

Monet paints our distance from objects.

GUSTAVE GEFFROY

While moving all around the motif, Monet creates great arbitrary spaces which invade the composition.

JEAN CLAY

No doubt, Monet saw the Japanese prints which Ingres was looking for before him and whose influence — quite manifest with Manet, Guys, Whistler, Degas, Redon

and Lautrec — grew stronger in Europe, with every passing year, from the middle of the century to its end. Like in the Japanese prints the painter means to express the play of the earth's physiognomy and the reflections of the air in the eyes of the earth, i.e. in rivers and in the sea. However, while Hiroshige or Hokusai combine in one single image the countless impressions scattered from one end to the other of their existence, Claude Monet, under the impression of a second, creates a multitude of possible images of the season and of the moment of that second. And thus the oriental pattern and the occidental analysis reach the same result.

It was certainly for the first and only time in the history of painting that the name given to this movement suited it, at least if we consider only the work of Claude Monet and Sisley, most of the works by Pissaro and the first attempts of Cézanne and Renoir. It is the flashing visual sensation of the *Moment* which a long and steady analysis of the quality of light and of the elements of colour enabled a few painters to grasp in its fleeting, infinite and changing complexity. While searching for universal changes, it fails to notice the form of objects, the lines that mark their limits and the tone that defines them. It perceives nothing but the luminous, coloured vibrations of the crust of nature. However when it grows weaker and changes, it leaves the eye of the painters clear, it offers them a wealth of direct sensations which nobody before had experienced in such a subtle, vivid and complex form; it provides them with a new, firm instrument and contributes, through its very intransigence, to the further liberation of imagination, a prisoner so far of a plastic idealism and a literary constraint which had borne all its fruit in the past four or five centuries.

ÉLIE FAURE

A landscape by Monet never develops completely a theme from nature and looks like one of the twenty rectangles we cut out of a panoramic canvas measuring a hundred square metres.

FÉLIX FÉNÉLON

. . .he painted without respite and often felt he was beneath the real. He could thus believe himself to be a realist, though today the most abstract colourists claim him as their master.

PIERRE DESCARGUES

. . .one can say that Monet clarified man's view of the world and improved his sense of colour for several generations to come. The devouring passion for light and colour effects and for the effects of matter as well that mastered him underlies one of the best trends of modern painting.

PHILIP HENDY

Matter in Venice often seems to dissolve itself into reflexes, when light seems to be as real and tangible as the object it falls on. Thus churches, palaces and bridges look like as many curtains of coloured light quivering ceaselessly in the mirror of the water. In this half aquatic, half terrestrial atmosphere, nature changes altogether and, imitating art, offers us sights as usual and shifting as the best impressionist paintings.

JOHN WALKER

. . . the technique the artist will use in order to represent this new vision, fresher, more dynamic and, obviously, more precise than in the past — the outcome of a more careful and sometimes more analytical scientific observation — will become quite expressive only when served by the division of tones, i.e. never by smooth brush strokes as was the custom with painters before, Delacroix excepted, but by somewhat mobile ones, placed side by side, visibly separated when you take a close look at them, and at the same time by colours whose tones, when they are not pure, will combine on the retina, never on the canvas, on the support of the painting.

GEORGE OPRESCU

A painter of the movement of light, of dreaming colour, of transparent atmosphere, of quivering light, of sparkling water, of the sun, of the cold, the wind, the fog, the smoke, etc., a painter of the evanescent. A landscape painter of seaports,

of the English Channel, of the banks of the Seine, of England, Holland and Venice, Monet no longer suggests matter — starting with the series of the Rouen Cathedral — and he only renders impalpable light in all its intensities and frequencies. The phantasmagoria of the changes between water and sky, of the chromatic and luminous furies haunts him in the series of waterlilies at Giverny, a musical painting in which he almost completely renounces form...

EUGEN SCHILERU

His most important victories are always the landscapes, in which for the first time the optic phenomena of nature are represented in their true dynamics: man himself participates in this natural, changing and passing atmosphere, and Monet tries to introduce him in *Le déjeuner sur l'herbe*, a composition of considerable size on which he has been working all these years...

We have too often heard repeated that Monet is nothing but the mechanical eye that faithfully records optic impressions with scientific dryness, the painter who brings out, in an extreme experimental way, his friends' quests, the programmatic, intellectual-minded revolutionary, the skilful decorator who gives away his limitations in his last paintings, splendid mistakes; these are fragmentary dry opinions which are far from doing justice to his talent as well as to his lyricism and delicate sensitiveness, so graceful and refined, so genuinely fragrant and original. Monet is indeed the first painter to have achieved the instinctive harmony between the eye and the feelings, between reality as such and its lyrical transformation, the real cornerstone of Impressionism; he does it all with the passion and faithfulness peculiar to his sentimental and stylistic make-up, which confers absolute coherence upon the road he follows and makes it almost necessary.

ALBERTO MARTINI

Monet never ventured into a subjective vision and he never abandoned the fundamental principles of his early paintings.

H. W. JANSON

Claude Monet is intoxicated with light and, two centuries later, his lyricism craving for open spaces meets Claude Lorrain's lyricism locked up in the rigorous architecture of will-power and reason. He perceives the sun before all the others, even when not yet up, even when the sky is overcast. Piercing through the clouds or coming from beyond the skyline, the sun floods the universe with a powdery shower of sunbeams which only his eye can see. The wave of light that the sun spreads all over the world is to him an infinite universe in which thousands and thousands of coloured atoms roam and cross each other, which the other people can see only as a whole. He distinguishes the summer sun from the winter sun and the spring sun from the autumn sun. The sun at dawn or the sun at twilight is never the same as the sun that shines for ten or fifteen hours running from sunrise to sunset. The artist watches it every minute rising, waxing and waning, he sees its unexpected eclipses and sudden changing course on the boundless surface of life whose features, timbre and accents change with every season, with every month and week, with the wind, the rain and the dust, with the snow and the frost. There are a hundred images of the same water, a hundred images of the same trees, and they are similar to laughter and smiles, suffering and hope, anxiety and fear in the same human face; they change with the strong light or deep shadow that envelops them, or with all the hues which separate deep shadow from strong light. Form is still present, of course, but it flees and hides like the form of those faces so mobile that the expression of the eyes and lips seems to be floating in front of them...

... In front of them is water, the sky, an immense changing light through which we dimly see palaces, bridges, trees, cliffs, towers stirring tremulously in the sea and the river, in a universal change — subtle and dancing — of coloured reflexes, of moving transparent shadows, sudden unexpected recesses of light and dark. Here are the wide expanses of the sea, sailing ships, clouds floating between water and sky. Here are sullen depths and luminous foam, here are ghosts of flowers under the mirror of the ponds. Here is the shade of leaves blending with the undulating algae in the lively streams. Here is everything that passes and trembles, everything that no one could fix

before him, everything that keeps passing and trembling once he has fixed it. Here is the mist, the sleet and hoarfrost, the lazy smoke of trains and sailing ships. Here is the fragrance of burnt grass, of flowering grass, of humid grass. Here is the cold, sudden thrill that congeals the colour of the world once the wind is up. When he paints the stone façades, the play of sunlight and shadow and of mist, and of the seasons, he makes them move like the surface of trees, like clouds, like the surface of water. He is the painter of the water, the painter of the air, the painter of the glittering reflection of the air in the water and of the water in the air, the painter of everything that floats, oscillates, prowls, vacillates, circulates between water and air. A shadow passes and it is only a fleeting gleam you can see in its depth, a distant arrow, the brow of a hillock, a flicker of light, and everything comes out again, for a second, only to dissolve and plunge into the sun. It is Venice, London, a French river, a canal in Holland, the sea in Normandy, the boundless realm of the air, of light, of twilight and of water.

ELIE FAURE

When Monet came back to France, in 1871, and started painting again in the company of Renoir, his palette became brighter the same as Renoir's in fact. When comparing the paintings they made together at Argenteuil, we realize that Monet continued to render glitter by means of contrasts of light and shade, while Renoir dissolved the whole scene into tiny patches of pure colour, which made him lose some of the precision of tones Monet excelled in.

KENNETH CLARK

Monet, who had made his first experiments *en plein air* and who was the most daring, most unbiased talent in this respect, became, if not a master, a most active and stimulating personality: little by little, through painstaking victories, his first static landscapes were replaced by others evincing a powerful dynamic vision he achieved through his deep insight into the continuous, always fascinating change of light and atmosphere.

ALBERTO MARTINI

It can be said that it was Monet who really invented the sea, for he is the only painter to have understood and represented it in all its changing aspects, its gigantic rhythms, its movement, its "infinite renewed reflexes, its fragrance."

OCTAVE MIRBEAU

For nothing is more difficult than to see the world with your own eyes as it really is; to be able to do it a painter needs genius. To be able to see beyond appearance, to reappraise the world in its pictorial perspective is the great discovery we owe to Impressionism, and perhaps to Monet in the first place.

OCTAVIAN FODOR

He was the first who proclaimed he wanted to free painting from anecdote; the very fact that he captioned one of his pictures *Impression, soleil levant* proves that he did not mean to represent a particular place but to definitely express a sensation, therefore an abstraction. He always wanted to place technique in the service of a tangible expression and the definition of art as nature considered to be the expression of a temperament that suits him better than any other artist; but he went to such extremes in expressing the priority of the artist's temperament that nature became — without his being aware of it — an almost subsidiary element which seems to be subjected to his vision. Oscar Wilde correctly wrote that after seeing Monet's paintings he no longer looked at the London bridges with the same eye.

RAYMOND COGNIAT

His unerring eye supported the plenitude and freshness of the new style which, despite the frequent assertions to this effect, was never tributary to any pre-established technical system. The clear yet seldom pure hues are now juxtaposed, now combined; the touch — spread, divided, transparent, thickened — always changes its form, size, density, adapting itself to the various kinds of matter, to the shades of light. Unity is achieved by the vibration of the atmosphere, the composition becomes organized through

16

the judicious arrangement of the fixed reference points and the subtle distribution of the mobile elements.

<div align="right">JEAN LEYMARIE</div>

Here is a new technique, extremely complicated and delicate, meant to suggest the vibration of the colours in nature. This trait distinguishes the impressionists from Manet. With an impressionist, a surface is never painted in one single tone, not even when it is the skin on the face or the general aspect of a nude. Fine threads and touches of colour brighter or fainter than the general tone will combine to make the surface of the local colour vibrate. If we look closely at the epidermis of some person, we always see red and brown filaments, pores, tiny elements which mix and still, from a certain distance, create the impression that the surface is smooth, glossy, done in one tone only, with some subtle gradations at the most, from a more vividly coloured portion to a paler one. There is in nature too the same disposition of tones, the same phenomenon which the impressionists make use of — exaggerating it, to be able to create the impression that everything is alive and palpitating.

<div align="right">GEORGE OPRESCU</div>

A fragment of nature, closed on both sides between rocks which maintain their equilibrium reciprocally, between trees, hills or fragments of architecture which open up a broad vista on the landscape that stretches far into the distance, this is the most frequent background ever since the Renaissance to the works of the Romantics... It is only the achievement of Impressionism, which when organizing a pictorial composition does without any "wings", that are an important turning point in this respect.

The *panoramic frame* does not necessarily require that the composition should be "framed in" on both sides. The boats float on the water, cut in two by the frame of the picture and seem to come from beyond the rectangle of the canvas, as is the case of Monet's work representing the fishermen of Sequana (1882).

Using the same device, the artist leaves some of the bridge in *La Grenouillère* (1869) outside the landscape and cuts in two the rock in *The Beach at Etretat* (1886). Such seemingly unimportant actions were brought to bear on the further development of landscape painting.

<div align="right">ALEKSANDER WOJCIECHOWSKI</div>

Monet, the true inventor of Impressionism, was the only painter who had the courage to carry his theories to their last consequences. Dissatisfied with his glittering landscapes from the South of France, he tried to prove that the object painted was not at all important, that the only real subject was the impression light made on the painter. He used to say to an American pupil that he "would have liked to have been born blind and recover his sight suddenly, so as to be able to paint without knowing what the object he saw represented." This is the most extreme and absurd definition of the aesthetics based on impression. In fact, Monet's technique made him rely on his subjects to a very large extent, and these were quite limited. It was only the sunlight on the water and on the snow that could give free rein to his prismatic vision and his luminous touches. No one has ever matched him in such paintings. However, in order to demonstrate his theories he chose cathedrals and haystacks for his experiments. This was a deliberate choice, no doubt, for he wanted to prove that man's most elaborate works, as well as the most unshapely, possess the same pictorial value for a painter of light.

<div align="right">KENNETH CLARK</div>

While Renoir owes something to Delacroix — he admits it himself in his *Parisian Women Dressed as Algerians*, of 1872 — while Degas owes something to Ingres and Manet to the Spanish painters, it is quite obvious that the most daring of them all was Monet, who was bold enough to measure his strength against nature without any intermediary. The future of painting lies in him more than in Manet. He never ceased to develop, to continue his experiments, returning, towards the end of his life, to the visions of great painting of his youth, this time however turned only towards light. Always dissatisfied — the great number of canvases he destroyed or mutilated shows it — he went from one daring act to another, sometimes disconcerting his admirers,

17

and our epoch could see in the painter of the *White Waterlilies* the pioneer of informal painting.

GERMAIN BAZIN

With the Impressionists — Monet, Renoir, Sisley — the basic colours: blue, red and yellow, are spread all over the canvas flickering and playing perpetually when laid side by side; they let the eye combine the various colours thus achieving perfect harmony.

CAMIL RESSU

. . . a painter like Monet can suggest the effect of the midday sun by exploring the dazzle that results from its glare, and such pictures will even gain in poetry from the artist's determination to achieve the impossible.

E. H. GOMBRICH

Claude Monet treats light waves the same as a musician does sound waves. The two kinds of vibrations become identical. Their respective harmony corresponds to the same ineluctable laws, and two tones are juxtaposed in painting as necessarily as two tones in harmony. Moreover, the various episodes of a series are linked together like the various movements of a symphony. The pictorial drama develops according to the same principles as the musical one.

GEORGE GRAPPE

But what was absolutely clear to me was the unsuspected power, previously hidden from me, of the palette, which surpassed all my dreams. Painting took on a fabulous strength and splendour.

KANDINSKY

His obvious predilection for the morning mists made people say that he used to sacrifice form to light effects. But it is only the routine of visual habit that can prevent one from seeing the infallible individual construction piercing through the luminous halo. . .

DENIS ROUART

. . . Monet concerns himself with the motives in which water appears, with the houses and other objects on the banks reflected in it, with the thousands of tiny ripples stirring at the lightest breath of wind. Such are his views of Holland, the one of Zaandam more especially, or those of London that recall Turner, with light struggling hard to pierce the mist and reach the sluggish water of the river. The technique he uses in these cases improves with every new canvas. The brush strokes that must suggest the mobility and variety of reflexes in the water must be so varied and so expressive that we may consider it as one of the most difficult things to achieve in painting.

GEORGE OPRESCU

Monet, who is so enthusiastic about light, sacrifices everything to it; he resorts to the most extreme plastic means and tries to finish *Le chant des heures*, which Claude Lorrain had started two centuries before.

GERMAIN BAZIN

Never before had this field found anyone able to express its luminous poesy in its subtlest variations, with such vigorous truth. Never before was the ethereal undulation of a glorious spring morning in the tall grass of an orchard caught so perfectly in its yet so complex essence.

DENIS ROUART

Monet is not less scrupulous in the attention he gives to the linear structure of the composition than to the light and colour values. The slender, flexible columns of the poplars soar delicately to the sky spreading all over the canvas an endless veil of quivering verdure which the rosy flickering of the rising sun illuminate. The tangible presence of the forms and their subtle evaporation are felt alike in the morning atmosphere.

In 1890 Monet painted the "poplars" for three seasons running. The ornamental linear stylising that heralded the modern style combined with the moving undulations of the light become almost abstract in their refinement and purity. The finest variations of tones follow the network of light rectangles which create, in the sky and the water, the elaborate and sensitive geometry of this manner of painting.

DENIS ROUART

In his series of *Poplars* the artist was able to make us feel the impalpable presence of the air which separates us from these tall and frail structures rising in the light. Monet places his easel on a level with the water, which enhances the soaring of the great filiform trees whose contours are shredded by the sunrays.

JEAN CLAY

After many a hesitation regarding the connection between form and colours, he deliberately opted for the expression of the poesy of atmosphere made up of very luminous hues which formed a real film all around the object, soon to become an enchanted fairyland, almost a phantasmagoria. From the *Woman with Green Sunshade* (1887) to the series of *Poplars on the Eure*, his evolution is obvious: we may say that when Monet tried to capture the way in which light fell on one and the same object, he succeeded in composing a particularly new coloured universe, almost abstract in the original sense of the word. This is what Kandinsky unconsciously felt when, discovering Monet, he said that it was for the first time that he could see painting.

RENÉ HUYGHE

Monet dilated thus to the utmost the possibilities of sensation and was able to create a pictorial universe in which a more intimate poesy was making its appearance surpassing by far the naturalism of the beginnings: he was coming close to a *magic* which the symbolists were striving to discover through a more intellectual attitude.

RENÉ HUYGHE

To 'realize' his visual apprehension of the *motif* was the first problem, because of the difficulty, already mentioned, of finding a focus, a structural principle of any kind. The first stage in the solution of the problem was to select the suitable *motif*. The typical Impressionist, like Monet, was prepared to find a *motif* anywhere — in a haystack or a lily pond — it did not matter because his primary interest was in the effects of light. This led eventually to a degree of informality in his painting that was only to be fully appreciated and developed by another generation of artists half a century later. This was precisely one of the tendencies latent in Impressionism against which the 'temperament' of Cézanne instinctively reacted.

HERBERT READ

Ten years later, the "systematic" series were to appear; one of them, the *Rouen Cathedral* (1892—1894) was considered among the most significant. It comprised more than twenty variants and it is interesting to note that Monet almost always looked at it from the same angle. Nothing can prove that, with him, it is not the motif but the effect he creates at various moments of the day, in fine or bad weather, in the transparent air or in the mist, that is essential. Never before had anybody discovered so many distinct aspects in an object, while changing his place so very little; or rather never before was the marvellous and multiple reality of light and atmospheric phenomena rendered with such keen sensitiveness. They fascinate the artist so much that he sacrifices matter, the solidity and weight of things: the façade of the cathedral is reduced to a kind of finely coloured veil, an evanescent memory of its structure.

The forms become more and more blurred in the paintings Monet executed at the beginning of the 20th. century after the "Parliament" in London. Enveloped in a blue or purple mist which dilutes the yellow, orange and pink hues of a phantomatic sun, the building is nothing but a ghostly apparition which a breath of wind could shake. We are thinking of Turner even if we can find nothing of the latter's romanticism in Monet. For even if there is in him both an observer of nature and a visionary, he never plunges the world in the chasms of his dreams.

When in 1889 he started painting the *Waterlilies*, his starting point was nature still: the garden with a pond he laid out on his estate at Giverny. At first, the object could be easily discerned. Later on, however, the vegetation on the pond and its banks — waterlilies, daffodils, wistarias, weeping willows — will have vague outlines and the paintings will consist of patches of colour, streaks, brush strokes and flourishes, a tangle of colours powerfully asserting the fact that they are sufficient in themselves.

JOSEPH-EMILE MULLER
FRANK ELGAR

Impressionism was more than a trend or a stage in the development of classical art: it started an epoch in which man is made to hold a new place in space, within other bounds of reality. That is why this metamorphosis of the vision was not limited to light and colour only; it went beyond them irradiating in the eternal forms and fundamental structures of the world, conveyed not only by means of colour but also by volumes, sounds and works. The presentation at the Orangerie of Monet's *Waterlilies* and of the *musical commentaries* bearing the same name — the *"eight impressions for organ"* by Marcel Dupré — was not due to chance, and the effect of the interference between the art of sounds and the art of painting proves to be mirific.

OCTAVIAN FODOR

In the presence of nature an artist does not think of himself; he receives everything from nature, he is impressed by it, without further reflection and lets himself carried away by the joy of contemplation. It is the same case with Monet's cathedrals and "Waterlilies" or with *Iberia* and *The Sea* by Debussy.

PAUL COLLAER

From 1885 to 1890, Monet turned to a manner of painting in which a feeling of subjectivity became more and more prevalent, a feeling that took him to the frontiers of the unreal. He certainly searched a lot; first in the sense of improving matter, making it record a world which was ever more vivid, expressed through tinted oblique strokes, very clear in the canvases at Giverny and Etretat which Signac greatly admired.

RENÉ HUYGHE

Monet's own efforts had just diverged in a new direction which became apparent when he exhibited in 1891 at Durand-Ruél's a series of fifteen paintings representing haystacks at various hours of the day. He explained that in the beginning he had imagined that two canvases, one for grey weather and one for sunshine, would be sufficient to render his subject under different lights. But while painting these *Haystacks*, he discovered that the effect of light changed continually and decided to record a succession of aspects on a series of canvases, working on these in turn, each canvas being devoted to one specific effect. He thus strove to attain what he called *instantaneity* and insisted on the importance of stopping work on a canvas when the effect changed and continuing work on the next one, "so as to get a true impression of a certain aspect of nature and not a composite picture." . . .

. . . It may be doubted whether Monet really meant to "discredit the object" in his attempt to observe methodically and with almost scientific exactness the uninterrupted changes of light on various motifs. His studies of haystacks were followed by similar series of poplars, of the façade of Rouen Cathedral, of views of London, and of waterlilies in his garden pool at Giverny, as well as of different aspects of Venice. He became disgusted with "easy things" that come in a flash, although it had been precisely in those "easy things" that he had manifested his genius for seizing in the first impression the luminous splendours of nature. The stubbornness with which he now pursued his race with light — he himself used the word *stubbornness* in this connection — resulted in frequently brilliant solutions of the problem he tried to solve, but this problem itself remained close to being an experiment and imposed severe limitations. His eyes, straining to observe minute transformations, were apt to lose the perception of the whole. Thus Monet abandoned form completely. . . and sought to retain in a vibrant issue of subtle nuances the single miracle of light.

JOHN REWALD

In the series of *Rouen Cathedral* and in the *Waterlilies* more especially, we have the feeling that the model chosen is a pretext rather than an aim in itself, a pretext to let the lyrical domination of colour and light develop, we might even be tempted to say "a frenzy", for in no other painting can one feel such a powerful outburst of the instinct dominated by passion.

It is impossible not to see in this effervescence a liberation from any academism and an apology of the individual act which stimulated the audacity of fauvism and the theories concerning pure colour. It is impossible not to see in the musicality of the ponds at Giverny, which made his last years so luminous, something unreal that eludes the conventions of space and form, heralding the liberties taken by abstract painting; it is impossible not to see in the instability of the combination of hues and in the use of scientific phenomena to achieve visual effects, a prelude to the seekings of Op Art.

RAYMOND COGNIAT

We can distinguish the same victory of freedom, the same realisation of the value of sacrifice in the evolution of Claude Monet too — "the fighter with an unflinching soul and strong body" — for any painter deserving this name owes him lessons of art and life. Little by little he gave up painting figures, in which he excelled, as his *Déjeuner* and *Woman in White*, show, for such paintings placed him on a level with Courbet. First he started painting landscape and marines which helped him achieve more freedom and tackle a larger number of subjects. Then he gradually gave up picturesqueness and soon made only series of identical motifs and subjects (haystacks, poplars, cathedrals) with the only concern of adorning them with all his sensitiveness and knowledge as a colourist. The final apotheosis of the work is the series of *Waterlilies* in which he sacrifices everything to the play of colours, tones and shades. He concentrated and achieved in these sumptuous symphonies all he had wished to do in a lifetime.

PAUL SIGNAC

The painter made a decisive choice, a choice in which his whole will-power was involved and which would never change until his work was completed. Such choice made the painter reach the *colouring he wished for*, so different from the accepted colouring, from the copied colouring. This wished for, deliberately chosen colouring, a combative colouring, enters the struggle of the fundamental elements.

Let us consider the struggle between stone and atmosphere. One day, Claude Monet wanted the cathedral to be aerial indeed — aerial in its substance and even in the very care of its stone masonry. And the cathedral absorbed in the bluish mist the whole blue substance that the mist had absorbed from the blue sky. Monet's entire picture comes to life in the transfer of blue hues, in the alchemy of blue hues. This way of attracting the power of the blue hues seems to bring the whole cathedral to life. You feel it in its two towers quivering with all its blue hues in the vast atmosphere, you see it responding, with its thousands of blue tints, to all the movements of the mist. It has grown wings, blue wings, undulating wings. Fragments of its tower tops evaporate, freeing themselves imperceptibly from the geometry of lines. An hour's impression would never have created such metamorphosis of the grey stone into a celestial one. It was necessary for the great painter to feel dimly the alchemical voices of elemental transformations. Out of a motionless world of stones he created a drama of the blue light.

No doubt, if there is no participation — coming from the very depths of one's imagination when viewing the material elements — in the usually excessive character of the aerial element, this drama of the elements and the struggle between the earth and the sky will remain unknown. The painting will be accused of lacking reality at the very moment when, to invite contemplation, it should penetrate into the very core of elemental reality, following the painter in his primitive will, in his unshakeable belief in a universal element.

Some other day there is another elementary dream that prevents him from painting. Claude Monet wants the architecture of the cathedral to become a sponge of light which should absorb the ochre colouring of a sunset into all the edges of the masonry, into all its ornaments. So, in this new canvas, the cathedral becomes a gentle star, a *fauve* star, a live being sleeping on a warm day. When the towers received the aerial element they seemed to be exulting in the celestial heights. But this time they are

21

nearer the earth, more terrestrial, flickering no more than a fire does among the stones of a fireplace.

The amount of reverie a work of art contains becomes mutilated if, when contemplating form and colour, one does not add some meditation on the energy of matter which feeds forms and projects colour, if one does not feel the stone "agitated by the inner effort of combustion." Thus, from canvas to canvas, from the aerial to the solar canvas, the painter has achieved a transmutation of matter. He has implanted colour inside matter. He has discovered a fundamental material element to help him implant colour. He invites us to deep contemplation when inviting us to feel for the élan with which objects are coloured and thus made dynamic. Out of stone he has created, in turns, mist and warmth.

To say that the "edifice" is bathed in an enveloping twilight or in a brilliant one would mean saying too little. For a genuine painter objects create their own atmosphere, any colour becomes irradiation, any colour reveals some secret of nature.

GASTON BACHELARD

The stone itself is alive, we feel it passing from the life that was to the life to come. Carefully chosen, the twenty states of light in the twenty canvases arrange themselves and supplement one another to form a complete evolution. The monument, the great witness of the sun, is vibrating high up with the élan of its imposing bulk, which he sacrifices to the struggle of light. The endless solar flood coming from infinite space breaks into luminous billows that fill its depths, its carvings, its powerful undulations or live vaults, making the stone sparkle with the glitter of the prism or become subdued in clear obscurity.

GEORGES CLEMENCEAU

A last comparison: a church seen by Millet, at Gréville, another one seen by Monet, at Vétheuil.

The former is a block and the eye controls its volume, neatly drawn, emphasized by shadows, by its own matter, a rugged stone, distinct, of the earth and of the grass.

The latter is nothing but an approximate condensation of light in a place which reflects it, a coloured vapour, analysed separately until you become dizzy with it, something nobody was able to do before him; a barely distinct vapour, a mirage of its own reflex in the moving water. At last painting has captured the most delicate flower of reality, like the coloured powder which the butterfly leaves on a finger when you touch it, but the butterfly has flown away...

RENÉ HUYGHE

And still *The Waterlilies*, belonging to Monet's last period of artistic creation, are the most stirring, the most purified part of his art and, at the same time, the climax of Impressionism... A crucial moment not only in the history of painting but also in the history of the human mind, more precisely in the history of the liberty of the human mind. That is why André Masson called his murals at the *Orangerie*... the *Sistine of Impressionism*: the Sistine of the vision transforming the world into a magical world of musical colours which are nothing but projections of his inner ectasies, a burning stake of colours on which the external world is all afire and thus is able to speak about the soul.

Everything here is vibration, pure transformation. The forms have dissolved in the murmuring luminous radiations, in the quivering azure reflected by the waves; ghostly flowers are still visible, in places, agianst green and blue flames. Matter has become impalpable. The objects are only condensations of light. It is only the thrilling stir of colours, in their finest nuances, that is still perceptible. In this sanctuary you are surrounded on all sides by a chromatic musical fluid which, like some *Chorus mysticus*, sings an almost inaudible song:

Das Unbeschreibliche
Hier ist's getan [1]

... Filling this inward road to the end it was quite natural that Monet should come, in *Les Nymphéas*... to something apparently paradoxical: forms disappear

[1] Here the ineffable becomes an act (Goethe, Faust, II)

leaving behind pure illumination, expressed sometimes by a few allusive signs borrowed from the outside, at other times by hues which have undergone a real musical mutation.

GEORGE POPA

Water, light and earth combine in an inextricable fusion over the pond at Giverny. Monet derives from it the inspiration of his last years.

The dim flicker of the "nymphéas" paves the way for informal abstraction.

JEAN CLAY

Monet's *Waterlilies*, a magnificent work of the ageing painter, which he offered France on the occasion of the 1918 armistice, the landscape he made at *Vétheuil* and in *Venice*, and the *Rouen Cathedral* will always be masterpieces of poesy, while *Gardens with Pond at Giverny* seem to be a hymn in praise of the sun.

A. BOUGIER

The vortex of the immaterial, toward the end of his life, drew Monet to an art without form or depth, bordering on the abstract. For twenty years he stubbornly tried to fix on the canvas the most ethereal clouds, the most fleeting mirages of the sky and water. He created a painting of ambience which never draws attention to any particular object but reaches sensitiveness through impregnation.

JEAN CLAY

I

Youth regained, faithful subjection to the rhythm of succeeding nights and days, punctuality in awaiting the dawn, all this makes of the waterlily the flower of Impressionism. The waterlily is a moment of the world, the morning of the eye...

II

Yes, everything is new in water at dawn. And what vitality this cameleon river must possess to be able to respond so easily to the kaleidoscope of the newly born light! Only the life of the purling water can refresh all the flowers. The slightest movement of an inner water heralds the beginning of some floral beauty.

The rippling water possesses inside it the palpitation of flowers, a poet says. One more flower makes any water more complicated. A straighter reed gives it the finest ripples. And the image of the young water iris gushing forth through the green thicket of the waterlilies, its amazing triumph, the painter must convey to us in one breath. Here it is, with all its blades drawn, with all its cutting leaves which, from high up, let the yellow tongue — as yellow as sulphur — hang over the waves, in a harrowing irony.

Should a philosopher dreaming in front of some painting by Monet representing water venture to do so, he would develop the dialects of the iris and of the waterlily, the dialectics of the upright leaf or of the leaf that rests on the surface of the water, calmly, wisely, ponderously. Isn't this the very dialectics of the water plants, one of them wanting to gush forth animated by who knows what rebellious feeling against its native element, the other faithful to it? The waterlily has understood the lesson of calm behaviour water gives one when asleep. With the help of such a dialectic dream we shall be able to grasp maybe, in its unimaginable delicacy, the sweet verticality that finds its expression in the life of the waters immersed in their sleep.

Yet the painter senses all this by instinct, and can find in reflexes a sound principle which creates, vertically, the calm universe of the water...

III

... You never linger in a dream, by the water, without formulating a dialectics of the reflection and of the depth. It seems that some unknown substance, rising from deep down in the water comes to feed the reflection. The silt is a mixture of tin and quick silver which keeps operating. It adds the dark hues of matter to all the shadows that it touches. The bottom of the river holds in store, for the painter, subtle surprises.

From time to time, a stray bubble rises from the depths of the whirlpool: it keeps bubbling on the still surface of the water, the plant is sighing, the pond is groaning. And the dreamer who paints it all is seized with silent compassion for a cosmic disaster.

Is there any deep-buried evil lying under this floral paradise? We must recall, together with Jules Laforgue, the evil seated in the flowering Ophelias.

And white waterlilies on the lakes where Gomora lies asleep.

Indeed, on the brightest morning, the water, even when shaking with laughter or garlanded with flowers, conceals something grave...

IV

The world wishes to be seen: before it had eyes to see, the eye of the water, the large eye of the still waters was looking at the flowers opening. And it was in this reflection — who could maintain the opposite! — that the world first became aware of its beauty. In like manner, only after Claude Monet gazed at the waterlilies, did the waterlilies in Ile-de-France become more beautiful and larger — they float on our rivers more leafy than before, more solemn, and wise like the faces of some lotus-children...

Claude Monet understood the infinite comfort of beauty, this encouragement given to men to hanker after all that leads to beauty.

GASTON BACHELARD

The last Monet, the one belonging to the prodigious series of paintings at the Marmottan Museum...

Waterlilies, carnal sanguinolent candles, evanescence become density, supremely transcending contrasts. The eye that sees and accepts the world — in its physical, stratified density — the eye which not only reflects it, the eye — a lotus plunged in chasms of vibroid matter, like an antena inextricably caught in the algae of the world: in the train of vital scoria of reality.

We are far from the tyrany of impressionist transparencies, from all that is fragile in the play of reflexes. We are — fiercely and absolutely — *in the retina, without any meditation:* painting appears like a slice of the retina, like a section in its irreducible immediacy — where there is no room for the corrections of perspective. This last stage of Monet's painting — so fantastic because it is an inner stage (so much so that it comes to abolish any coordinates) — changes the cordial impressionist iridescences into bridges thrown over flames. Direct, as only viscera and our most intimate self are, without a trace of metaphorical programme, the fluidity of the world becomes solemn, the same as an infernal river!

DAN HĂULICĂ

The reconciliation between realism and lyricism will always be Monet's great victory before he died and at the same time the acme of his Impressionism...

DENIS ROUART

Monet's death meant the disappearance of the last master of the unique, astounding pleiad that constituted the group of impressionist painters. He died, like Ingres, at a time when the ideas he stood for had long since ceased to be topical. The first of the impressionists to have met with success, the only one to have witnessed success changing into real triumph, towards the end of his life he lived in utter isolation and undoubtedly felt embittered at the violent attacks of the younger generations against the ideas he had imposed at the cost of years of strenuous work.

ELIE FAURE

CHRONOLOGY AND CONCORDANCES

1830 *Birth of Camille Pissaro at Saint-Thomas, in the Antilles. E. Delacroix paints* Freedom Guiding the People.

1832 *Birth of Edouard Manet in Paris.*

1839 *Birth of Paul Cézanne at Aix-en-Provence and of Alfred Sisley in Paris.*

1840 Birth of Claude-Oscar Monet (November 14) in Paris, Lafitte Street.
Birth of Odilon Redon and Auguste Rodin in the same year as Monet.
Turner paints: Sunrise at the Castle of Norham, The Evening Star *and* Boat with Slaves.
Victor Hugo writes Rayons et Ombres.

1841 *Birth of painters Renoir, Bazille, Guillaumin and Berthe Morisot, "stars" of the first magnitude in the constellation of the Impressionists.*

1845 At the age of 5, Monet together with his family leaves for Le Havre, in Normandy, where his father keeps a grocery. Less contemplative, though in love with the sea, inclined to be satirical and showing an interest in caricature, the young independent-minded Monet roams about the cliffs and makes caricatural portraits of the people he meets, in which he shows a very great skill.
As a child, he exhibits his caricatures in a shop-window in order to sell them; thus he unwittingly "competes" with the "disgusting" *marines* by Boudin, a painter for whom he felt a dislike he soon repressed; he came to value him so much as to accept him as his master and friend. In his memoirs Monet mentions the following about Boudin: "With boundless kindness he saw to my training as a painter. Little by little my eyes opened and I was able to really understand nature, and at the same time I came to love it."

1849 *Courbet completes* The Stone Breakers.

1850 *Boudin, who meanwhile had become a friend of Millet's, widens the scope of his experiments, paints reproductions after works in the Louvre, studies carefully nature, the value of impression, of the pictorial motif, of the ensemble and builds up an artistic personality for himself, which was to have a decisive influence upon Monet.*
Millet paints The Burial at Ornans.

1855 *Whistler and Pissaro come to Paris and take part in the artistic life of the time. Degas and Manet study at the École des Beaux Arts, while Renoir learns the ornamental technique in a porcelain factory. The most important event of the year is the "National Exhibition" where works by Ingres, Delacroix, Th. Rousseau, Courbet and others are most conspicuous.*

1856 *Hugo writes* Les Contemplations.

1857 *Charles Baudelaire publishes* Les fleurs du mal.

1859 On the advice of Boudin, Monet leaves for Paris. A first revelation for him is the painting Salon where he becomes enthusiastic about Rousseau's landscapes, is delighted at the "verve and movement" in some paintings by Delacroix and exults in Corot's canvases which he considers "real miracles."
Monet becomes an habitué of the Brasserie des Martyrs sharing in the atmosphere of lofty spiritual élan of the place.
Courbet, Baudelaire and Boudin meet at Le Havre. Together they discover the scenery and atmosphere of Honfleur where they live on the Saint-Siméon farm.
Starting from direct observations Baudelaire will soon praise "the meteorological beauty" of Boudin's landscapes. Birth of Seurat.

1860 Early in the year Monet visits the great exhibition of modern painting in Boulevard des Italiens (Delacroix, Corot, Courbet, Millet) which fills him with enthusiasm owing to the serious lesson in the sublimation of the real it gives and to the means of expression suited to the state of mind of the epoch. He never notices the presence of an Ingres or a Meissonier. At the Académie Suisse — where like many other landscape painters he studies anatomy "free of charge" — he becomes acquainted with Pissaro. In April he goes with him to do landscapes at Champigny-sur-Marne. In autumn Monet is called up and sent to a mountain corps in Algeria, a difficult though brief experience, not devoid of interest for the sensitive artist, as he himself was to write later on: ". . .the impressions of light and colour I accumulated at the time, were to become organized only later; yet the germs of my future quests must be sought here."

1861 *Delacroix completes the frescoes in Saint-Sulpice Cathedral in Paris. Baudelaire was to appreciate its "supernatural colours, splendid and elaborate, the deliberately more epic drawing". Rewald notes that, with the great romantic, the subtlety of the composition comes from the fact that, as the frescoes were to be seen from a distance, the artist "executes them in broad, distinct touches which, from a distance, blend and make the hues look fresher and more energetic."*

Manet's painting Spanish Guitar Player *is accepted at the Salon.*

1862 Monet falls seriously ill in Algier and is sent to Le Havre where his father, alarmed at the prospect of his return to the army, decides to spare no pains and keep him at home. His passion for painting becomes more and more overwhelming. Works hard in the company of Boudin. In the same period Monet rediscovers Jongkind; he admires the ethereal lyricism of the Dutch painter, the delicate substance of his inspiration, his keen mind. He will write: "I owe him the final training of my eye."
In November he comes back to Paris and, with the help of Toulmouche, enters the studio of Gleyre. Here he establishes a close friendship with Renoir, Bazille and Sisley.
Manet paints Music at Tuileries *which he will exhibit at the Martinet Gallery on March 1, 1863. Birth of Debussy. Lecomte de Lisle publishes his* Poèmes barbares.

1863 In spring Monet together with his friends of Gleyre's atelier settles at Chailly-en-Bière, in the Fontainebleau forest.
The Salon des Réfusés *(Manet, Pissaro, Jongkind, Guillaumin, Whistler, Cézanne) and the scandal caused by* Le Déjeuner sur l'herbe *by Manet, which the French Emperor considered "indecent", are the most important events of the year.*
Monet and Bazille live for a time in a flat in *Place de Fürstenberg*, from where they can watch unseen, in dumb admiration, Delacroix's "hand" at work.
Death of Delacroix. Birth of Paul Signac.

1864 Monet and Bazille go to live at Honfleur. Boudin and Jongkind join them. Jongkind's experience who had painted — in varying conditions of light — two paintings representing the apse of Notre Dame Cathedral "once seen in the silvery light of a winter morning, another time under the blazing sky of a sunset" (John Rewald) suggested to Monet an interpretation suited to his temperament. A proof thereof are: his later "cathedrals".
Birth of Toulouse-Lautrec.

1865 For the first time Monet exhibits two "marines" at the Salon, enjoying great success. The paintings represent views of the Seine estuary at Honfleur: *La Pointe de la Hève* (The Cape of Hève) and *L'Embouchure de la Seine à Honfleur* (The Mouth of the Seine at Honfleur). Paul Mantz, the columnist of the "Gazette des Beaux-Arts", commenting on *The Mouth of the Seine*, has the feeling of a wonderful revelation.
Paints *Le Déjeuner sur l'herbe*, no less famous than Manet's, though the completed picture (?) is dated 1866. "In fact", art critic Denis Rouart holds, "this work restitutes the heroic ideals of the young revolutionary artist, eager to go beyond Manet's earlier example and to assert unreservedly the importance of *plein-airism* as a basic element of the new aesthetics." Completes *The Road to Chailly-en-Bière*.
In autumn, the painter together with Daubigny, Courbet and Whistler works at Trouville. Paints the landscape *Road Near Honfleur in Winter Time*.
Manet exhibits his Olympia *which is unfavourably received. After the "incident" he decides to go to Spain for a time.*

1866 Sends to the Salon *The Green Dress* or *Camille*, which represents the model who was to become his wife. Completes *Women in the Garden* at Ville-d'Avray and *Terrace near Le Havre* at Le Havre. Meets his friends regularly at the *Café Guerbois*.
The three "views" he painted from the roof of the Louvre, *Saint-Germain-l'Auxerrois*, *The Garden of the Infanta* and *The Quay of the Louvre*, date from the same period.

1867 On account of his reduced circumstances, his people force him to separate from Camille — she is left in Paris where she gives birth to Jean Monet — and to go to live for a while with his aunt M^me Lecadre, at Sainte-Adresse. Paints *The Beach at Saint-Adresse*.
In autumn the painter returns to Paris, where Bazille receives him. He joins his wife and son and tries, despite his hardships, to regain his equilibrium.
Death of Baudelaire and of Ingres. Birth of André Bonnard.
The World Exhibition: the artistic event of the year.

1868 As his poverty grows worse, he attempts on his life at the inn where he lives with his wife and son.
Thanks to M^me Gaudibert, who commissions him to paint her portrait, he spends a peaceful summer at Fécamp.
Short stays at Bonnière-sur-Seine and Étretat.
An international maritime exhibition is organized at Le Havre. Monet, Boudin, Manet and Courbet send some of their works there.
Birth of Vuillard.

1869 Settles at Saint-Michel, near Bougival and paints La Grenouillère, together with Renoir. Monet's work expresses the qualities of an unexpected coherent impressionist technique.
Birth of Henri Matisse.

1870 The painter officially marries his "model" Camille Doncieux (June 26).
At Trouville, he completes — among other paintings. — *Two Women on the Beach* and *Hôtel des Roches Noires*, still showing traces of Manet's thicker manner of painting, although the same paintings reveal more clearly than ever his "unmatched sense of atmospheric life."
The Franco-Prussian war breaks out (July 19). Setting up of the Third Republic (Sept. 4).
In September, because of the panic caused by the war, Monet takes refuge in London where he meets Daubigny who introduces him to art dealer Durand-Ruel.
Bazille is killed in action at Beaune-la-Rolande (November 28).

1871 *The Paris Commune (March 18 — May 26)*
Courbet is imprisoned at Sainte-Pélagie for his attitude in favour of the Commune.
Monet meets Pissaro again in London.
Together they visit the great museums, showing particular interest in the art of Turner, Constable and Old Crome.
Less true to himself, Monet will not admit the *real* influence Turner's landscape exerted upon him. Here he makes sketches and drawings, deriving his inspiration from the scenery along the banks of the Thames and from Hyde Park, studies the effects of the mist, of the snow etc. Travels to Holland (Zaandam), "attracted by the picturesque windmills with their red wings, the immensity of the skies over the flat lands, the canals with their boats, the cities with their houses that seemed to grow out from the water." (Rewald). He also discovers the "mystery" of the Japanese prints.
From Antwerp he goes to France where he stays for six years at Argenteuil.
Here, together with Renoir, he begins to use "a comma-like brushstroke, even smaller than the one they had chosen for the works at La Grenouillère, a brushstroke which permitted them record every nuance they observed. The surfaces of their canvases were thus covered with a vibrating tissue of small dots and strokes, none of which by themselves define any form. Yet, they contribute to recreating the particular features of the chosen motif and especially the sunny air which bathed it, and marked trees grass, houses, or water, with the specific character of the day if not the hour." (Rewald).
Birth of Rouault.
1872 *Impression, soleil levant,* the birth certificate of Impressionism is exhibited in Le Havre.
"Tackles" deliberately an industrial landscape in *Unloading Coal.*
The Romanian painter Theodor Aman paints The Turks Routed at Călugăreni.
1873 Stays on at Argenteuil and paints sailing boats. He makes friends with the amateur painter Gustave Caillebot who enables him to paint views along the Seine from the craft of Caillebot. Executes *The Poppies, Railway Bridge at Argenteuil* and *The Gladioli.*
1874 Opening of the first group exhibition at Nadar (Boulevard des Capucines). Exhibits five canvases and seven sketches in pastel. *Impression, soleil levant* and *Boulevard des Capucines* are on show on the same occasion.
Paints *Sailboats in Bad Weather* at Argenteuil, *Summer, The Bridge at Argenteuil.*
"The magnificent series of *Sailboats on the Seine at Argenteuil* marking the lasting vocation of the painter of atmospheric light in its most fleeting aspects, will be achieved in such conditions. This tendency is manifest in the cracking of masses; his strokes — inspired by the reflexes of the slightly undulating water, rippling and purling or broken by very small waves — separate, when shattering the surfaces." (Denis Rouart).
1875 In spite of the spectacular auction at Hotel Drouot, his circumstances are still very straitened. Fearing he will be evicted, he has recourse to the help of Dr. De Bellio, a Romanian physician (who buys *Impression, soleil levant*) and to the generosity of Emile Zola.
Death of Corot.
1876 Makes the acquaintance of Chocquet, a connoisseur. Invited to the castle of Montgeron by the art collector and banker Hoschedé, Monet paints *The Turkeys,* an ornamental work. Begins the series of *Gare Saint-Lazare.* During the auction at Durand-Ruel his painting *Camille Wearing a Japanese Dress* enjoys an unexpected success.
1877 Another stay at Montgeron. In April, he exhibits thirty-five canvases, landscapes of Montgeron (including *White Turkeys*) and seven paintings representing the Saint-Lazare Station.
The Swing *and* Ball at the Moulin de la Galette *by Renoir are also on show, besides works by Cézanne, Sisley, Pissaro, Berthe Morisot and Degas. Nicolae Grigorescu paints the portait of Georges de Bellio a medical man of Romanian origin, a friend aud maecena of most of the impressionists. The canvas is on show at the* Marmottan Museum. *Death of Courbet.*
1878 Early in January he settles at Vétheuil where he rents a house thanks to the help of Manet. His second son, Michel Monet, is born here.
Paints a landscape, *Vétheuil in Winter.*
1879 Death of Camille.
Entrance to the Village of Vétheuil.
1880 His one-man exhibition in the rooms of the magazine "Vie Moderne"
The fifth group exhibition is held in April.
Rodin completes The Thinker (Le Penseur). *Ion Andreescu paints* The Highroad.
1881 Goes on painting at Vétheuil and Fécamp.
Paints *The Thaw.*
Opening of the sixth group exhibition from which Monet, Renoir, Sisley and Cézanne are absent.
Zola's suppositions regarding the disintegration of the Impressionist movement come true.
Birth of Picasso. Ion Andreescu paints Winter in Barbizon. *Verlaine publishes* Sagesse.
1882 In December 1881 he decides to leave Vétheuil and stop at Poissy.
Attracted by the beauty of the cliffs and the poesy of the sea, the painter goes in turns to Dieppe, Pourville and Varengeville.
Opening on March 1st of the most important group exhibition in point of homogeneity.
The Girdle-cakes belongs to this period. "This painting reveals the irresistible dynamism of a Van Gogh." (Charles Sterling).
Monet has thirty paintings on show.

1883 In January he goes to Étretat, in Normandy.
In April he leaves Poissy for good and moves to Giverny together with the Hoschedés.
In December he goes, together with Renoir, on a short trip along the shores
of the Mediterranean, amazed at the fairy-like light of the scenery, the deep complexity
of the colour sensations. They visit then, Cézanne, at Estaque.
Death of Manet. Birth of Utrillo.

1884 A new trip on the coast of the Mediterranean, with a halt at Bordighera (where he paints
the landscape bearing the same name), at Menton and, in August, at Étretat with his family.

1885 Exhibits paintings, together with Renoir, at the International Exhibition held at the Georges
Petit Gallery. Temporary breach with dealer Durand-Ruél.

1886 Travels to Holland. Meets Gustave Geffroy and Octave Mirbeau.
The 8th and last group exhibition is opened in the middle of the summer.
The publication of The Work *by Zola hastens the breach between himself and Zola.*
Van Gogh comes to Paris.
Jean Arthur Rimbaud publishes Les Illuminations.
Nicolae Grigorescu paints his Landscape at Posada.

1887 *Gauguin leaves for Martinique.*

1888 Goes to live for a time in Antibes.
In July he revisits London, then returns to Étretat.

1889 Devotes all his energies to collect funds in order to purchase Manet's *Olympia* for the
French Government.
Exhibits works at the Petit Gallery together with Rodin.
Visits poet Maurice Rollinat, at Freselines in the Creuse.

1890 Begins to paint the series of *Poplars* and of *Haystacks.*
Death of Van Gogh.

1891 The series of *Haystacks* is on show at the Durand-Ruél Gallery.
Monet's paintings rouse a great interest, unprecedented in the history of Impressionism, and
firmly establish the painter's renown. Haunted by the significance and effect of his "reveries"
the painter with ever greater determination proclaims the principles of the art he cultivates.
Seurat dies suddenly.
Gauguin leaves for Tahiti thus completing the basic experience of his life. Paints Women of Tahiti.

1892 Monet marries M^me^ Hoschedé.
Continues the brilliant series of the *Poplars.*

1893 *The Rouen Cathedrals.* "The series of Rouen Cathedrals is the fullest and most spectacular
demonstration of his consummate skill in achieving such a work." (Denis Rouart).

1894 At Giverny, Monet receives the visit of Cézanne whom he introduces to Rodin, Clémenceau,
Geffroy.
Gustave Geffroy publishes The History of Impressionism.

1895—1898 Travels to Norway. Then goes to work at Varengeville and Pourville. Paints the *Cliffs.*
A new exhibition held at the Petit Gallery.
Death of Berthe Morisot (1895).
Death of Mallarmé (1898).

1899—1903 Paints *Pond with Waterlilies.*
Makes several trips to London and completes his impressions of the landscape along
the Thames.
Death of Gauguin and of Pissarro.

1904 Paints London, *Sunlight Effect in the Mist.*
Goes on painting *The Waterlilies,* which is also called "The Sistine of Impressionism."
Birth of Salvador Dali.
Paints the Garden at Giverny.

1905 *Brancusi enrolls for the Académie des Beaux Arts in Paris.*

1906 Monet works feverishly on his composition *The Waterlilies.*
Death of Cézanne. Picasso begins to paint Les Demoiselles d'Avignon.

1908 Visit to Venice.
Paints *The Doges' Palace* and *The Canal Grande.*

1909 Resounding success of the Waterlilies, on show at the Durand-Ruél exhibition.

1910 Becomes more and more engrossed in the plastic polyphony of the *Waterlilies* to which
he adds a new series.

1914 *André Gide publishes* Les Caves du Vatican.
Georges Braque paints the canvas Bach Aria.

1916 Clémenceau commissions him, on behalf of the French Government, to paint an ornamental
work whose subject is again the *Waterlilies.*
Manuel de Falla presents Nights in the Gardens of Spain.
The Romanian poet George Bacovia publishes Lead, *a volume of verse.*

1917 *Death of Degas.*

1918 *Guillaume Apollinaire publishes* Caligrams.

1919 *Death of Renoir.*

1922 Monet's eyesight is seriously impaired by his double cataract.

1923 Partially recovered, with great efforts he touches up the *Waterlilies,* the masterpiece of
his life. This work adorns — thus strictly observing the poet's wishes — the oval walls
of the *Orangerie* in Paris.

1926 Dies, amidst his floral paradise, at Giverny, on December 26.

SELECTIVE BIBLIOGRAPHY

WILLIAM C. SEITZ, *Monet*, Edizione Garzanti, 1973

IAN DULOP, *Van Gogh*, Weidenfeld and Nicolson, London, 1974

E. H. GOMBRICH, *L'Art et son histoire*, vol. 2. Editions René Julliard, Paris, 1967

E. H. GOMBRICH, *Art and illusion*, Phaidon Press, London, 1968

GIULIO CARLO ARGAN, *Studi e note. Dal Bramante al Canova*, Mario Bulzoni, Editore

PIERRE COURTHION, *Manet*, Verlag M. Dumont, Schauberg, Köln, 1962

ERNST FISCHER, *Von der Notwendigkeit der Kunst*, Verlag der Kunst, Dresden, 1959

JACQUES MICHEL, *Monet, de Giverny à Marmottan*, Le Monde, 9th. June, 1971

HERBERT READ, *A Concise History of Modern Painting*, Thames and Hudson, London, 1968

HERBERT READ, *The Meaning of Art*, Faber & Faber Ltd., London, 1931

HERBERT READ, *The Philosophy of Modern Art*, Faber & Faber Ltd., London, 1969

HERBERT READ, *Histoire de la peinture moderne*, Editions Aimery Somogy, Paris, 1960

WILLIAM FLEMING, *Arts and Ideas*, Holt, Rinehart and Winston, New York, 1961

JACQUES PAUL DAURIAC, *Meisterwerke des Impressionismus in den Sammlungen des Museums Marmottan*, in "Die Kunst", March 1974, Heft 3, B 4357 E.

ROBERT GORDON and CLAIRE L. JOYES, *Claude Monet in Giverny*, in "DU", Zürich, December, 1973

GERMAIN BAZIN, *Les chefs-d'oeuvre de la peinture moderne*, in "France-Illustration", Paris, 1954

ELIE FAURE, *Histoire de l'Art*, Editions Jean-Jacques Pauvert, Paris, 1964

JEAN CLAY, *L'Impressionisme*, with a preface by René Huyghe, Hachette, Paris, 1971

TUDOR VIANU, *Aesthetics*, Third Edition, Fundațiilor Publishing House, Bucharest, 1945

ANDRÉ LHOTE, *Les invariantes plastiques*, Hermann, Paris, 1967

MAURICE GROSSER, *L'Oeil du peintre*, Marabout Université, Verviers, 1965

RENÉ HUYGHE, *Les puissances de l'image*, Flammarion, Paris, 1965

RENÉ HUYGHE, *Dialogue avec le visible*, Flammarion, Paris, 1955

PHOEBE POOL, *Impressionism*, Thames and Hudson, London, 1967

LÉON DEGAND, DENIS ROUART, *Claude Monet*, Editions d'Art Albert Skira, Geneva, 1958

JOSEPH-ÉMILE MULLER, FRANK ELGAR, *Un siècle de peinture moderne*, Fernand Hazan Editeur, Paris, 1972

ALBERTO MARTINI, *L'Impressionismo*, Fratelli Fabbri Editori, Milan, 1967

JOHN REWALD, *The History of Impressionism*, Secker & Warburg Ltd., London, 1973

JEAN LEYMARIE, *L'Impressionisme*, Editions d'Art Albert Skira, Geneva, 1959

NOËL MOULOUD, *La peinture et l'espace*, Presses Universitaires de France, Paris, 1964

CHARLES BOULEAU, *Charpentes, la géométrie secrète des peintres*, Editions du Seuil, Paris, 1963

ANDRÉ LHOTE, *De la palette à l'écritoire*, Editions Corrêa, Paris, 1946

PAUL SIGNAC, *D'Eugène Delacroix au néo-impressionisme*, Editions scientifiques Hermann, Paris

RENÉ GIMPEL, *Journal d'un collectionneur*, Calmann Lévy, Paris, 1963

ERWIN PANOFSKY, *Renaissance and Renascences in Western Art*, Almqvist & Wikselis, Gèbers Forlag AB, Stockholm, 1960

CAMILLE MAUCLAIR, *Le secret de Watteau*, Albin Michel, Paris, 1942

GASTON BACHELARD, *Le droit de rêver*, Presses Universitaires de France, Paris, 1970

H. W. JANSON, *Histoire de l'Art* Editions Cercle d'Art, 1970

JACQUES LETHÈVE, *Impressionistes et symbolistes devant la presse*, Armand Colin, Paris, 1959

PIERRE FRANCASTEL, *Histoire de la peinture française*, II Elsevier, Amsterdam, 1955

PIERRE FRANCASTEL, *La réalité figurative*, Editions Gonthier, S.A., Paris, 1965

HENRY DAUBERVILLE, *La bataille de l'Impressionisme*, Editions J. et H. Bernheim-Jeune, Paris, 1967

DANIEL WILDENSTEIN, *Claude Monet, Biographie et catalogue raisonné, tome I; 1840—1881, Peintures*, La Bibliothèque des arts, Lausanne-Paris, 1974

* * * *Centenaire de l'impressionisme*, Editions des Musées Nationaux, 2nd edition, Paris, 1974

PIERRE DESCARGUES, *Le musée de l'Ermitage*, Editions Aimery Somogy, Paris, 1961

WILLIAM GAUNT, *The Observer's Book of Painting and Graphic Art*, Frederick Warne & Co. Ltd., Frederick Warne & Co., Inc. London — New York, 1964

L'opera completa di Claude Monet, 1870—1889, Presented from the writings of the painter and co-ordinated by Luigina Rossi Bortolatto, Rizzoli Editore, Milano, 1972.

REMUS NICULESCU, *Georges de Bellio l'ami des impressionistes*, Paragone-Firenze, 1970

LIONELLO VENTURI, *De Manet à Lautrec*, Albin Michel, Paris

LIST OF REPRODUCTIONS

60. RUE MONTORGUEIL DECKED OUT WITH FLAGS 1878
1878
oil
The Art Museum, Rouen

61. WATERLILIES POND HARMONY IN GREEN
1899
oil
Galerie du Jeu de Paume, Paris

62. ROSE GARDEN AT GIVERNY
oil
Marmottan Museum, Paris

63. THE JAPANESE FOOT-BRIDGE AT GIVERNY
c. 1923
oil
Marmottan Museum, Paris

64. YELLOW NIRVANA
1900—1922
oil
Folkwang Museum, Essen

65. GARDEN IN BLOOM
1923—1924
oil
Michel Monet Collection, Sorel-Moussel

66. VENICE, THE DOGE'S PALACE
1908
oil
Brooklyn Museum of Fine Arts, New York

67. VENICE, PALAZZO DA MULA
1908
oil
National Gallery of Art, Chester Dale Collection, Washington

68. LONDON, THE PARLIAMENT
1905
oil
Marmottan Museum, Paris

69. THE PARLIAMENT. SUN EFFECT THROUGH THE MIST
1904
oil
Durand-Ruél Collection, Paris

70. CAMILLE MONET ON HER DEATH BED
1879
oil
The Louvre, Galerie du Jeu de Paume, Paris

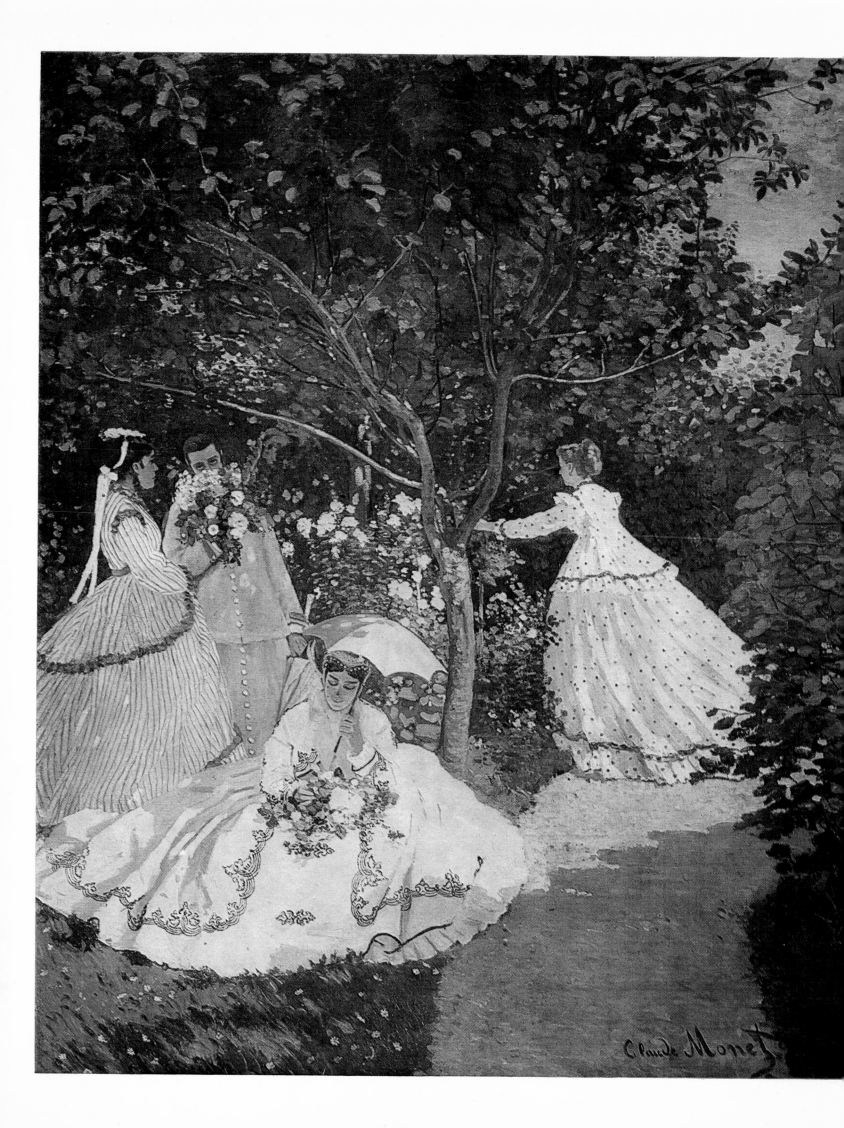

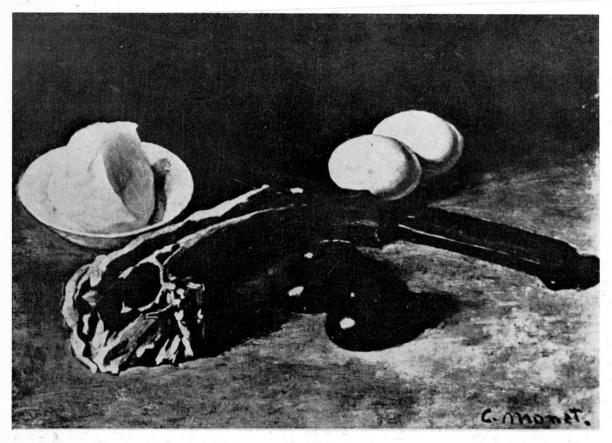

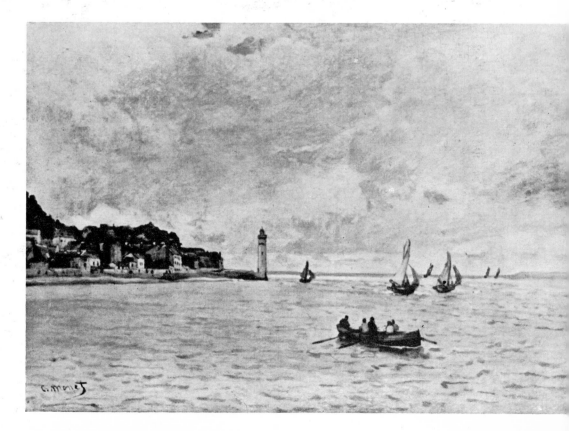

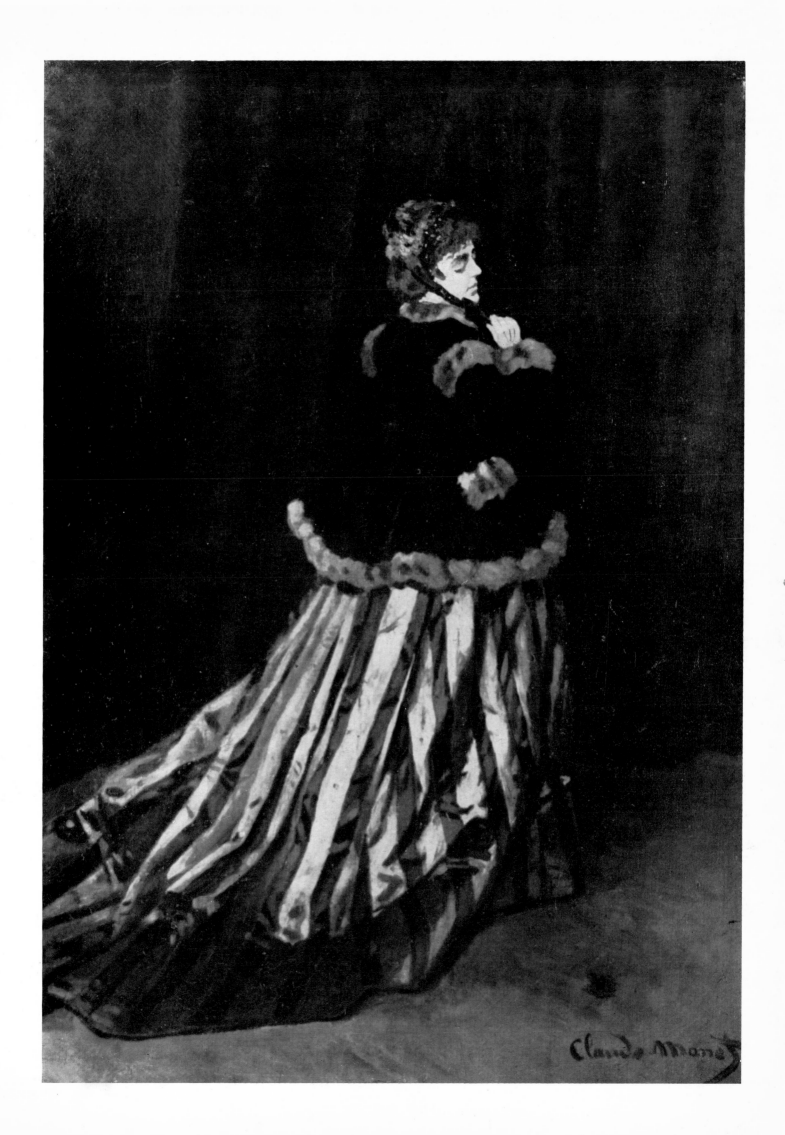

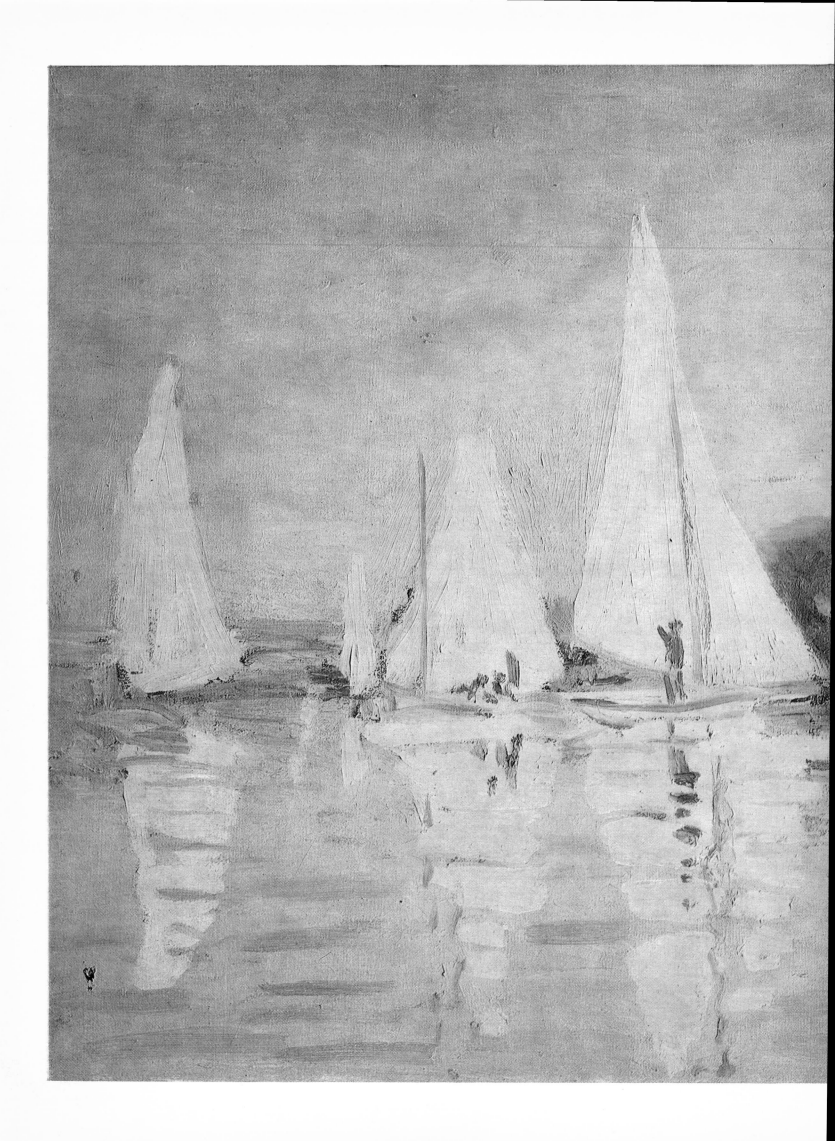

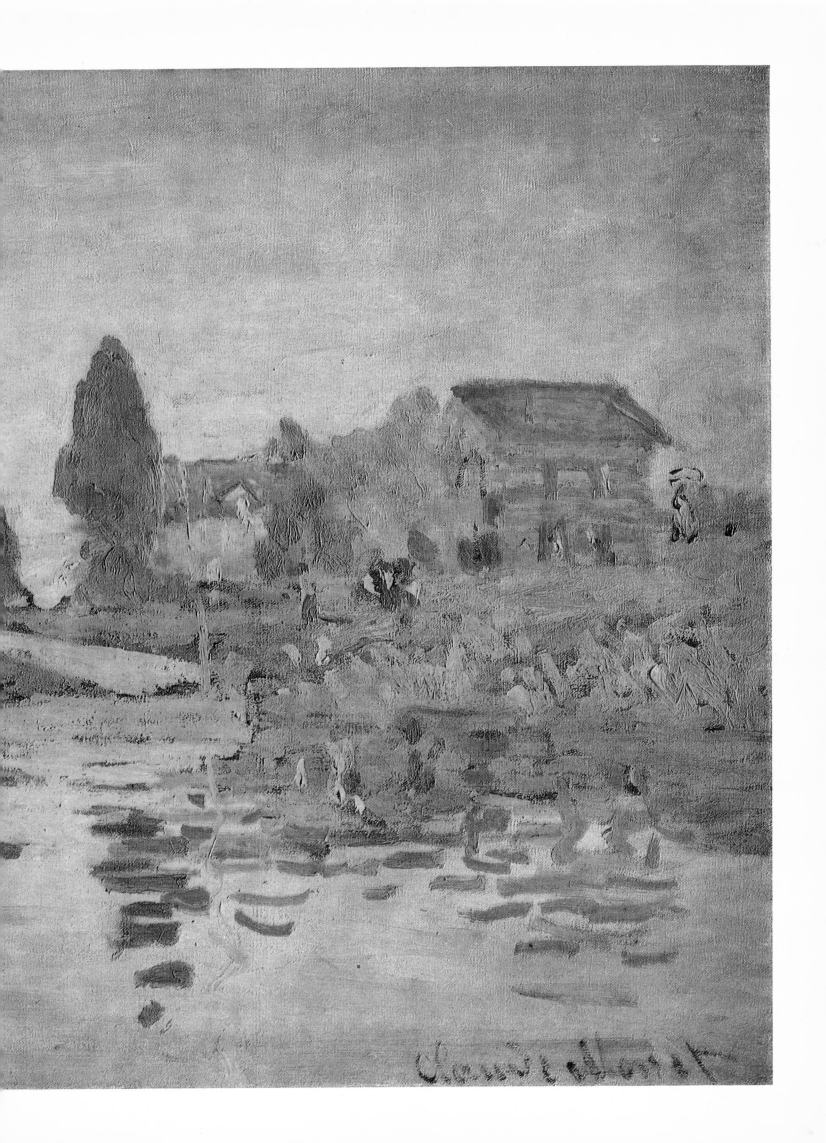

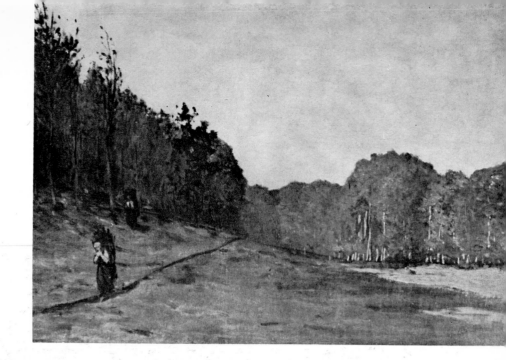

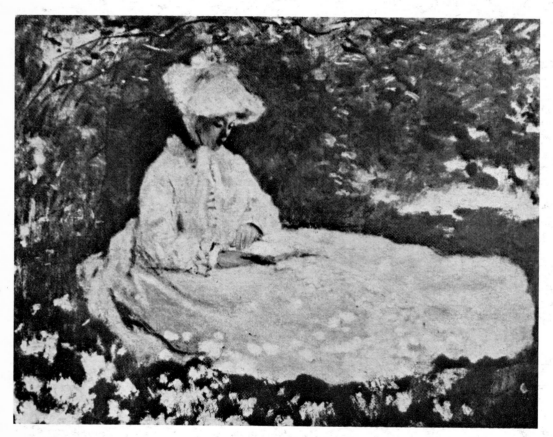

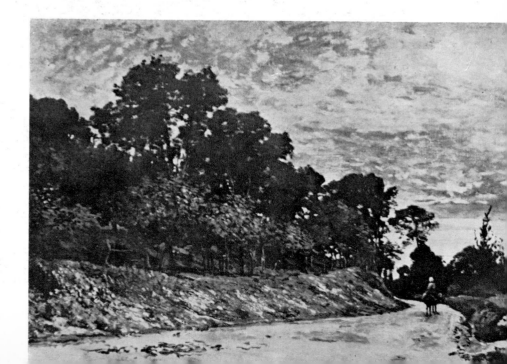

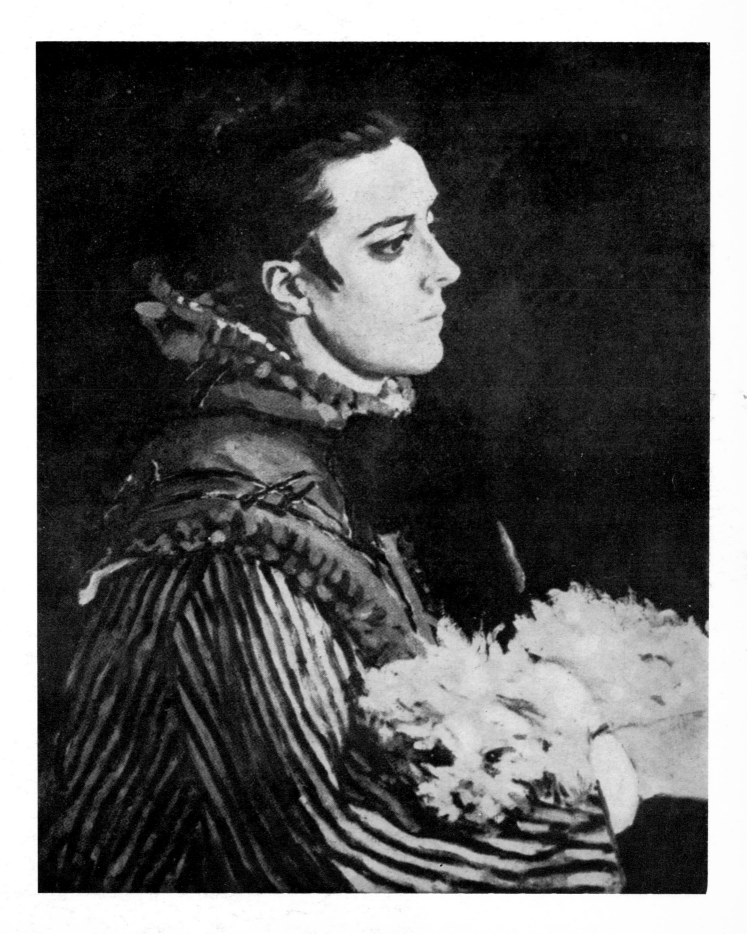

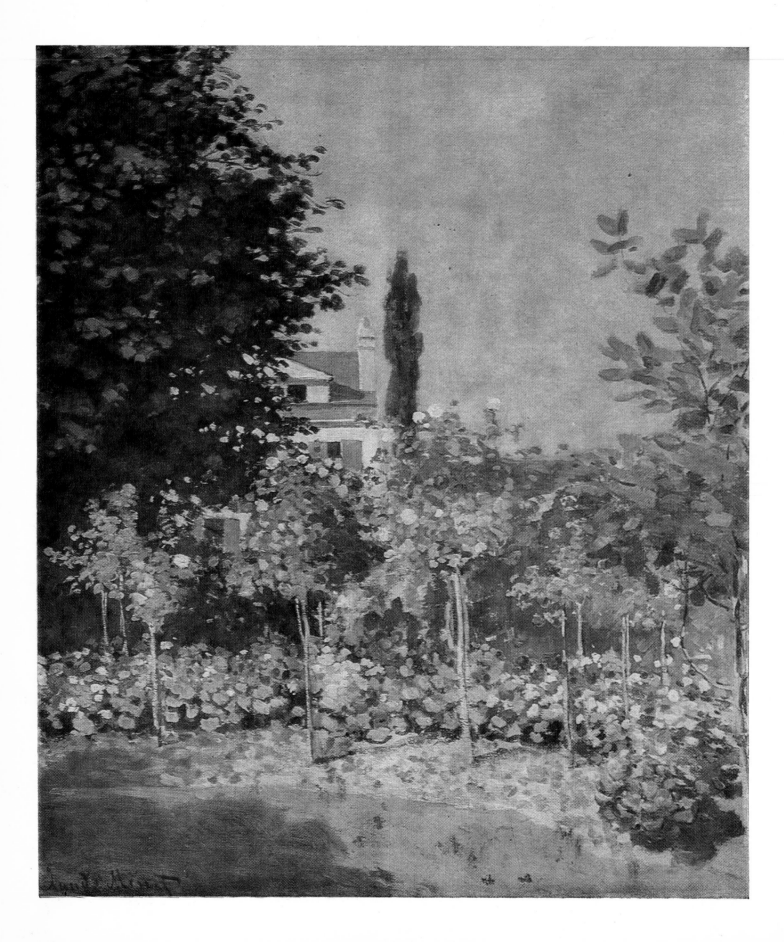

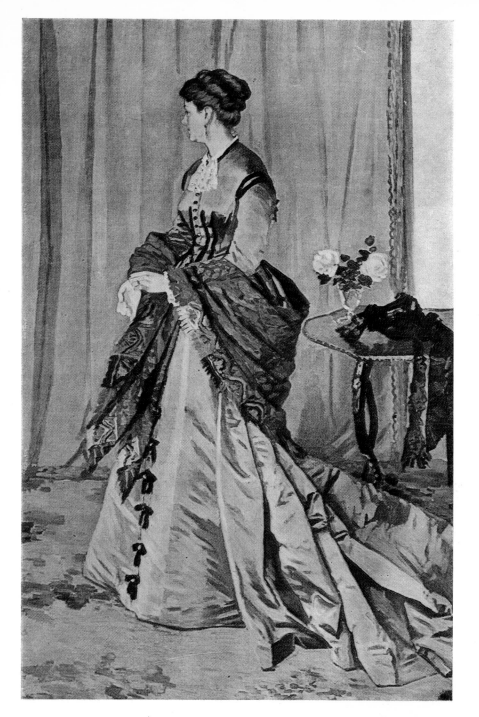

11. Portrait of Mme Gaudibert
12. Still Life with Melon

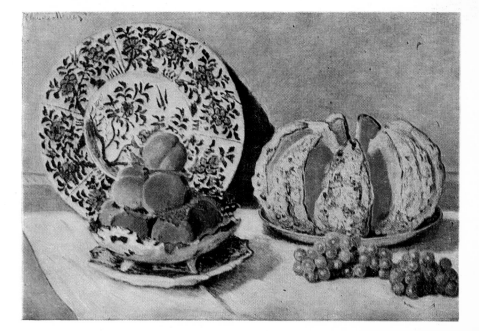

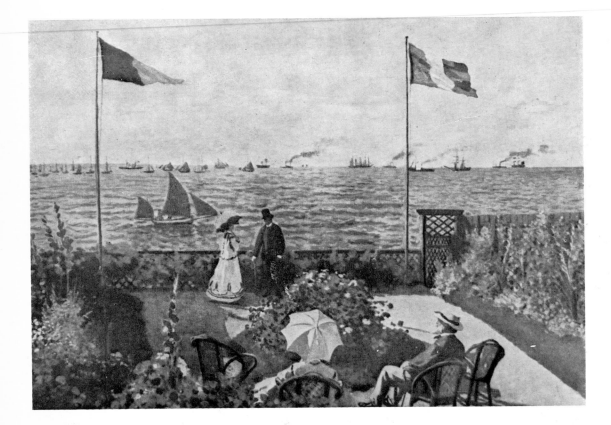

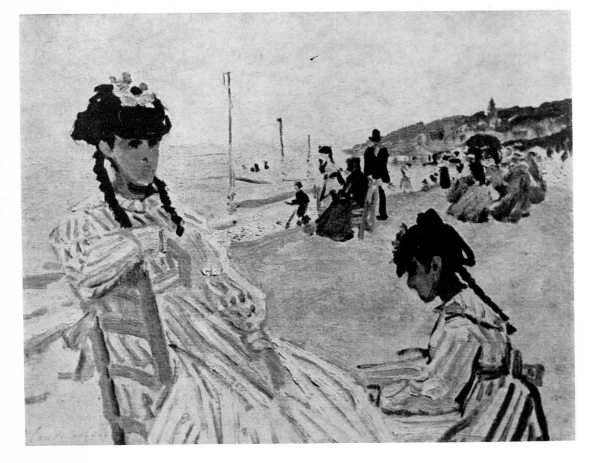

15. The Beach at Sainte-Adresse

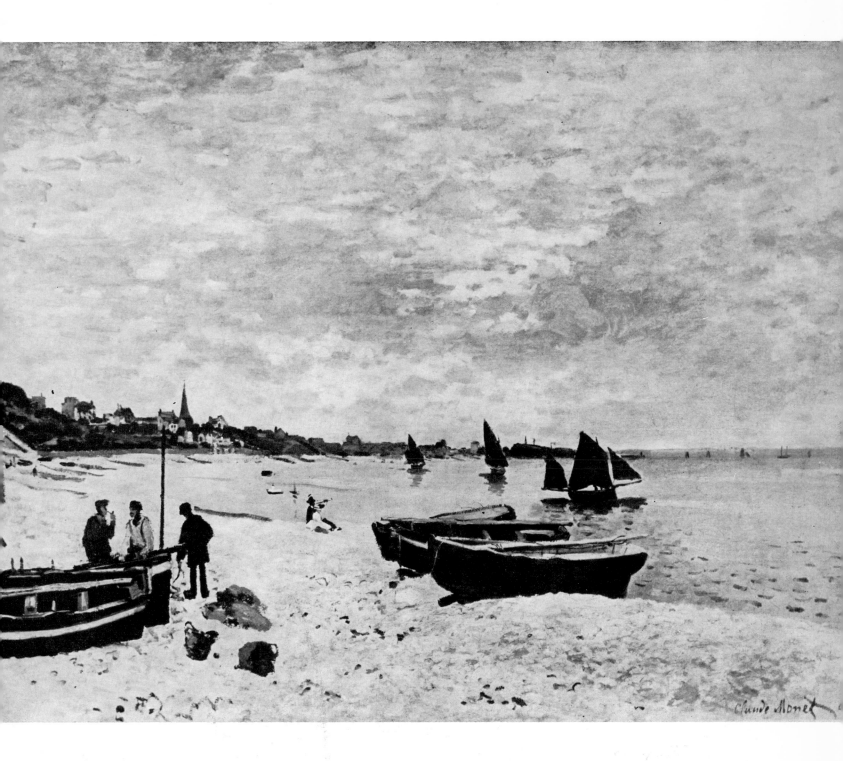

16. Impression, soleil levant

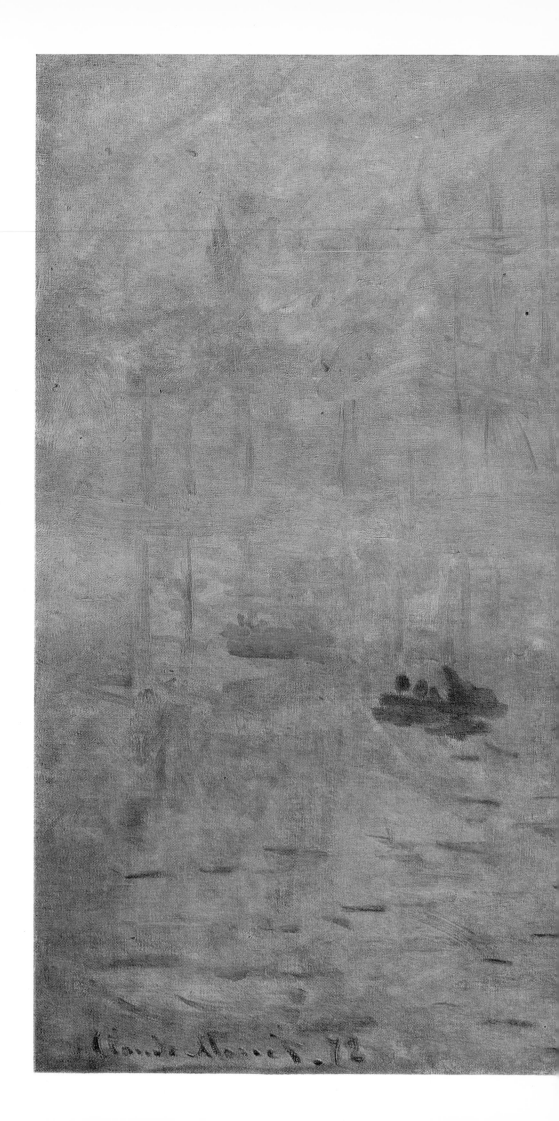

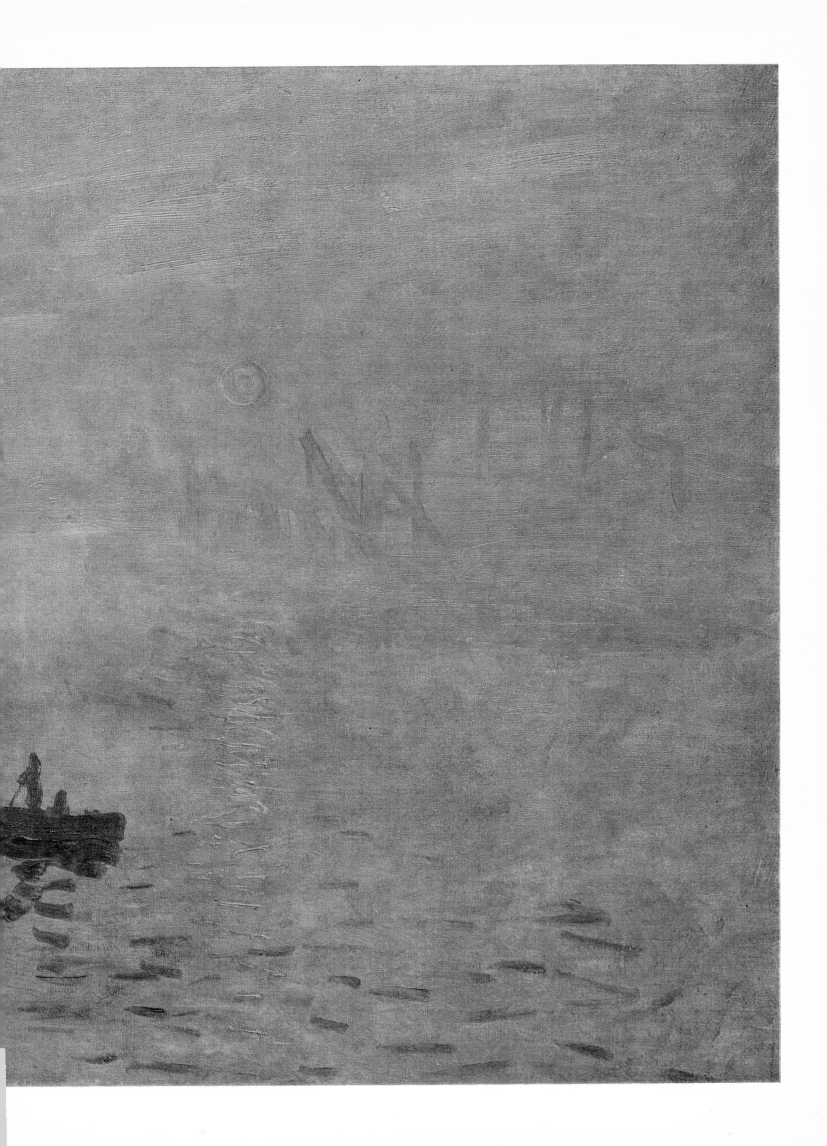

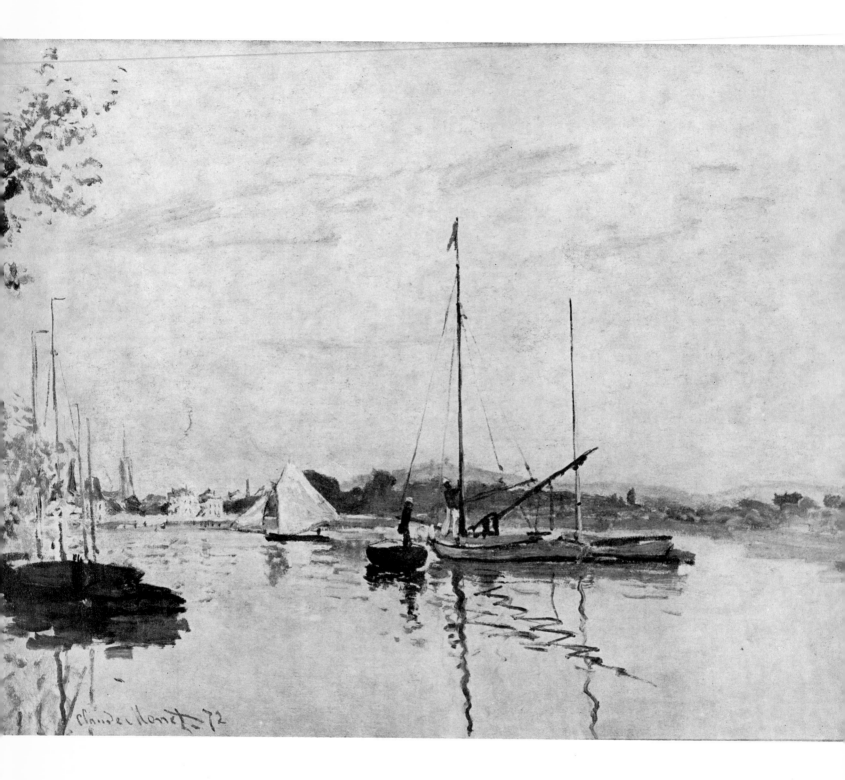

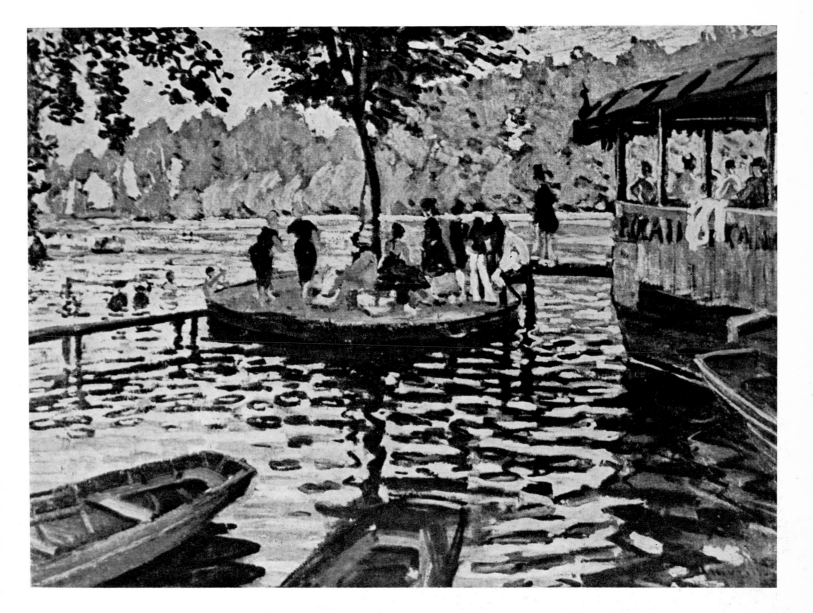

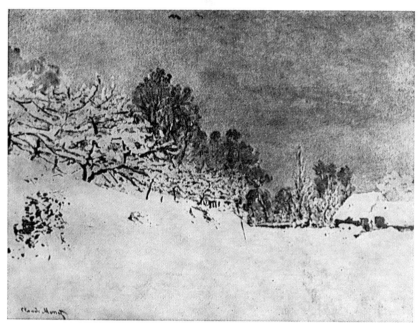

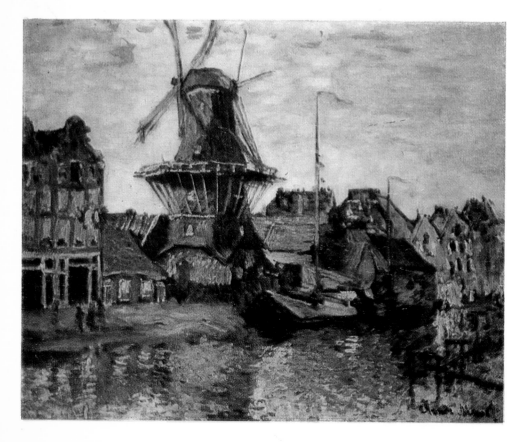

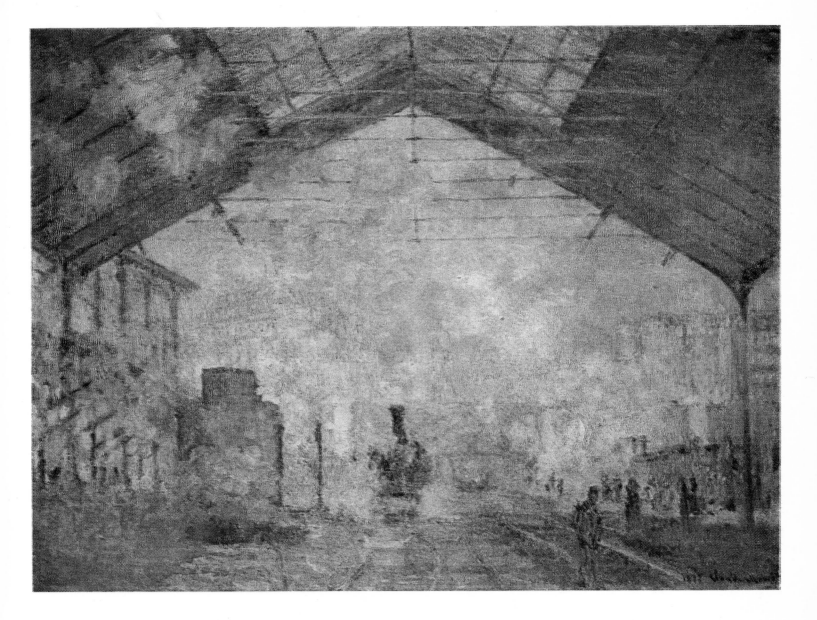

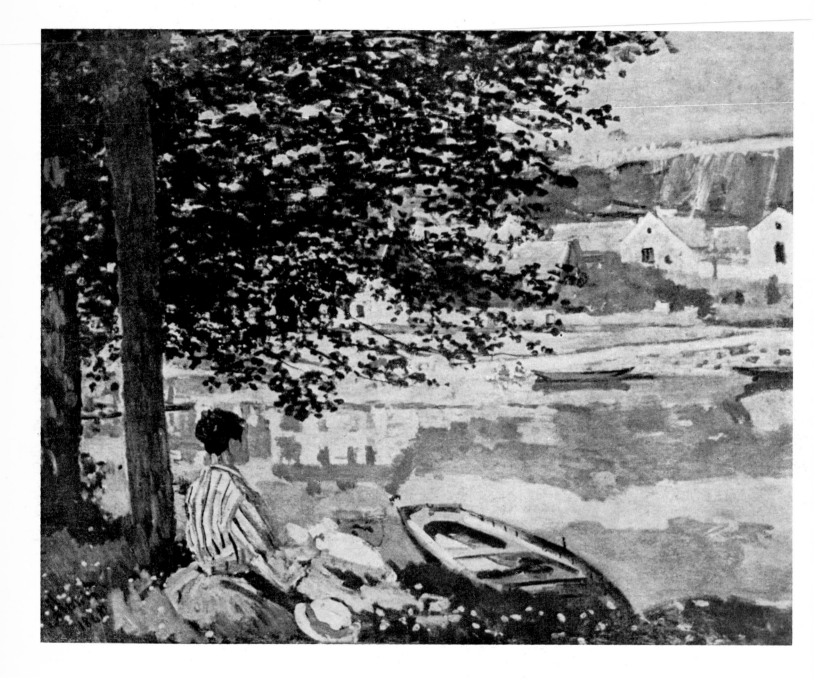

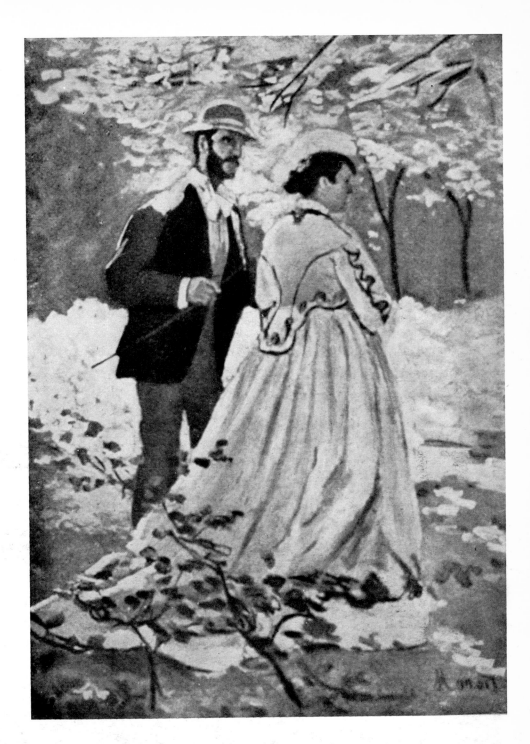

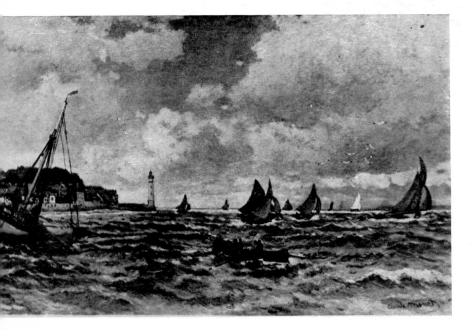

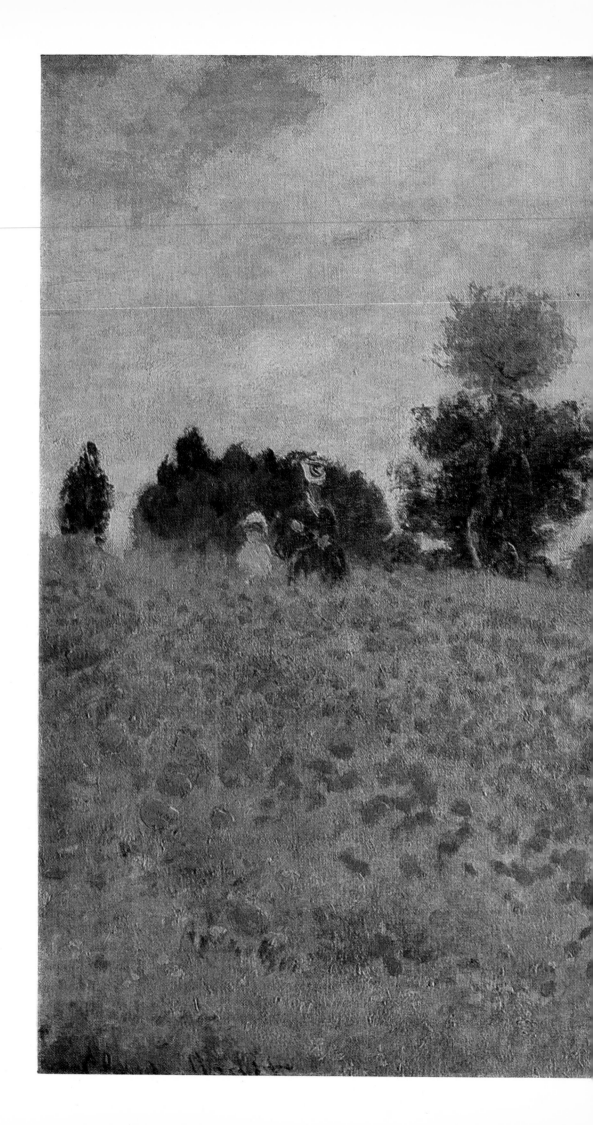

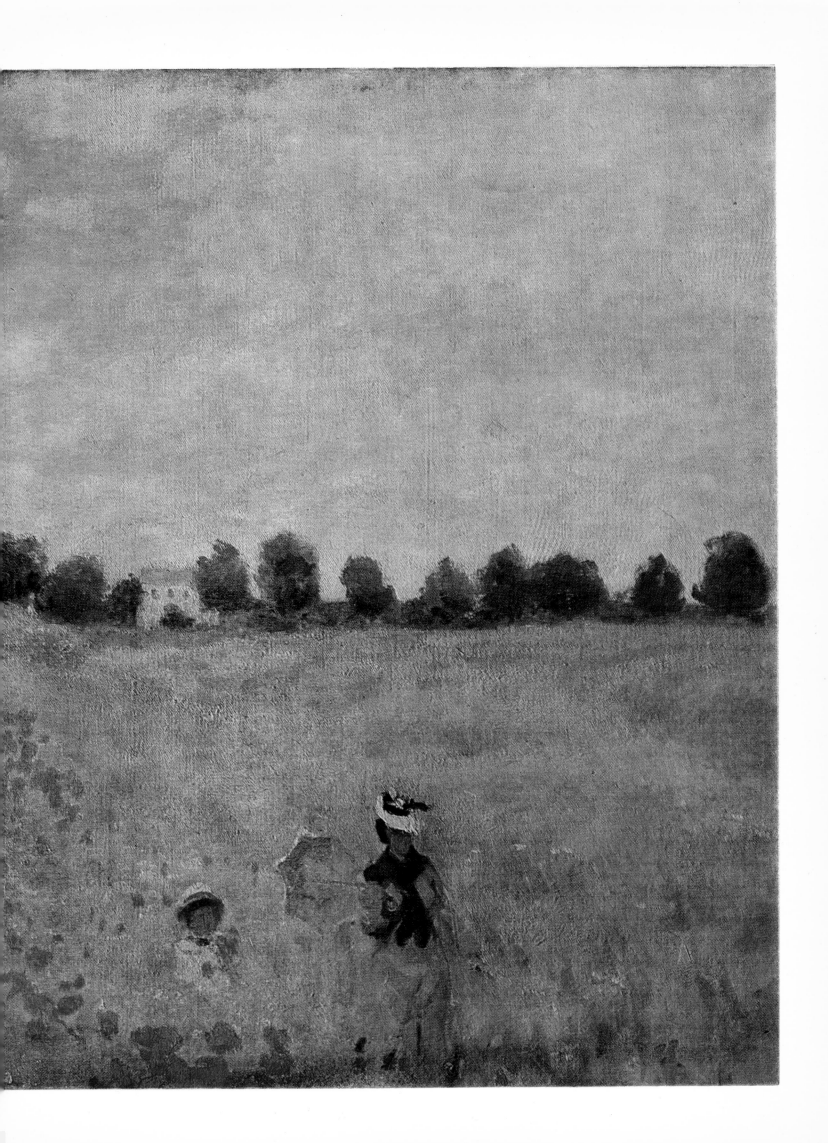

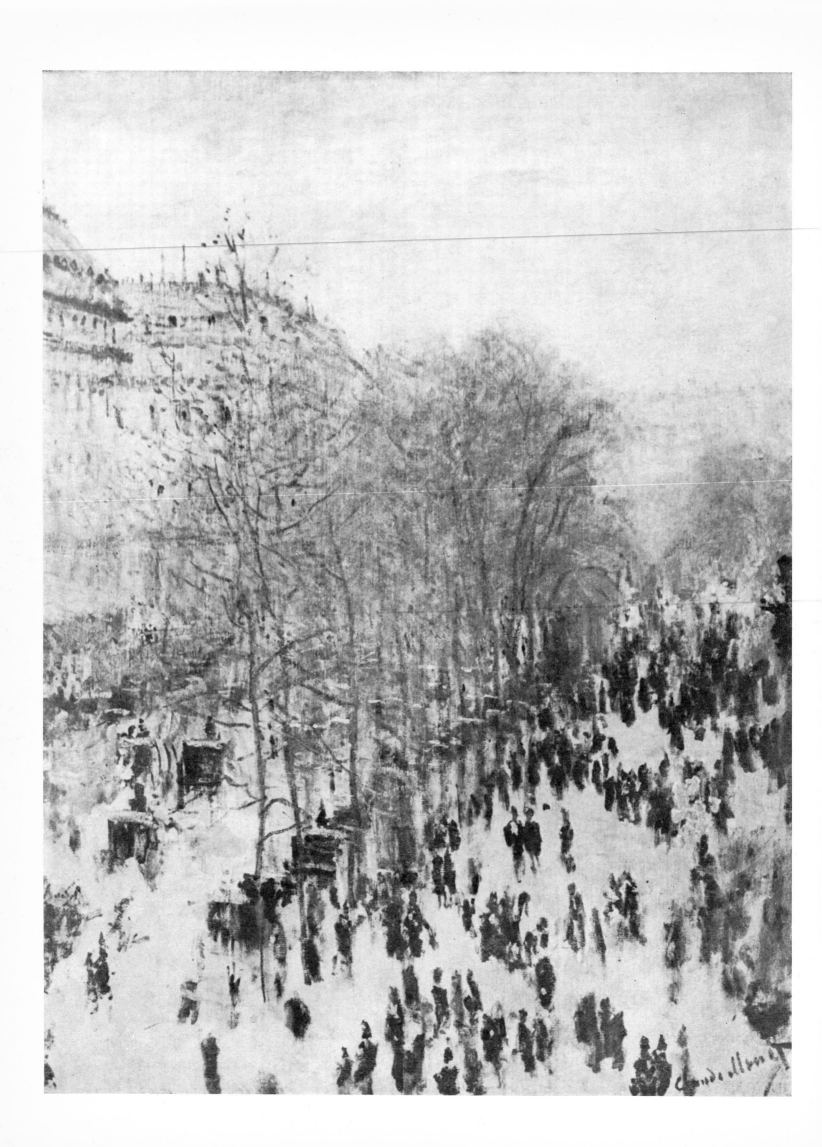

27. Le Boulevard des Capucines
28. Bridge at Argenteuil

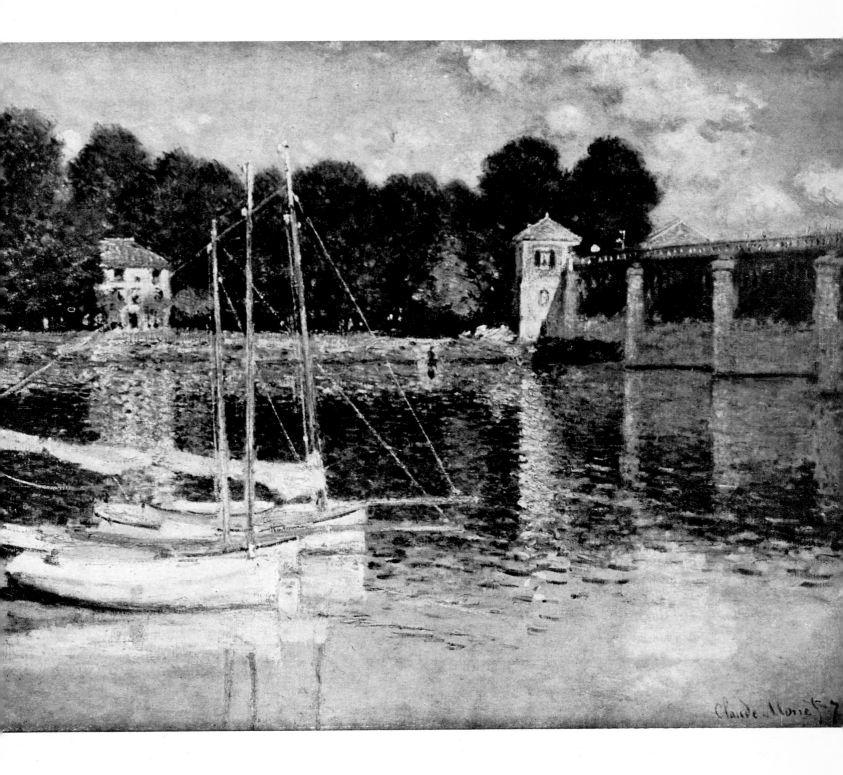

29. Le Déjeuner

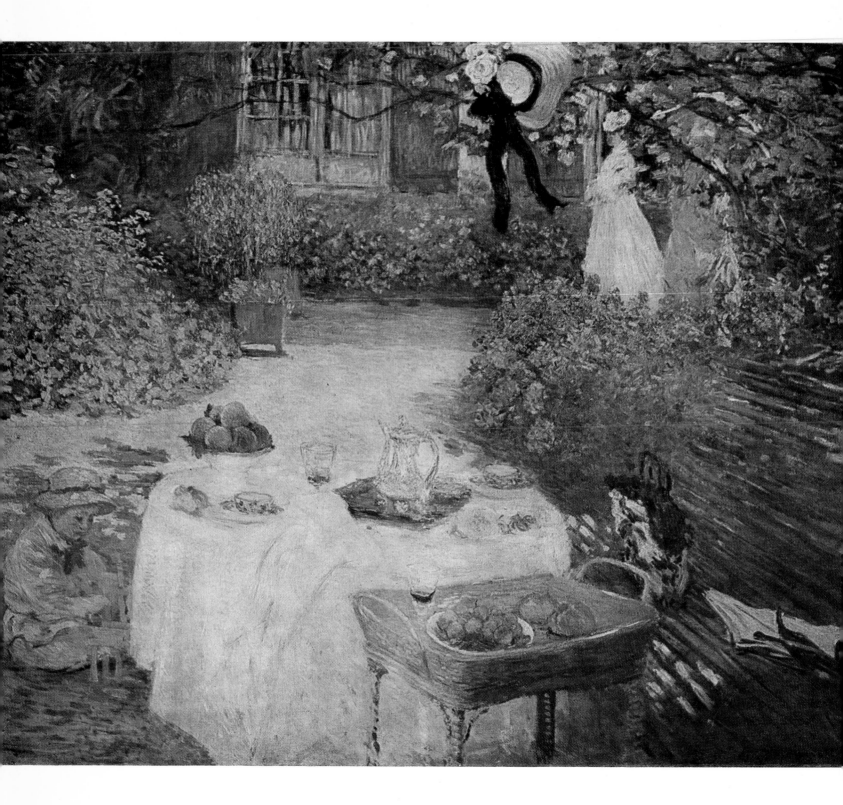

30. Les dindons blancs
31. Les dindons blancs (detail)

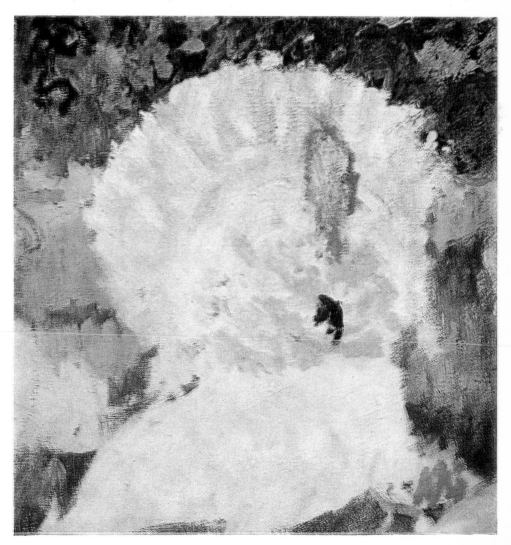

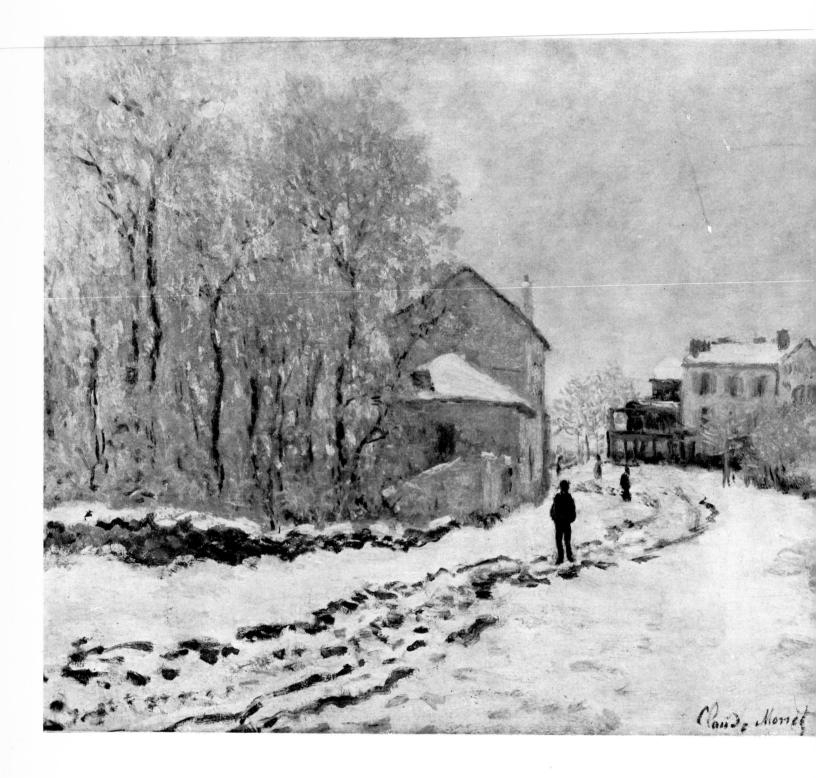

33. The Banks of the Seine (Spring in the branches)

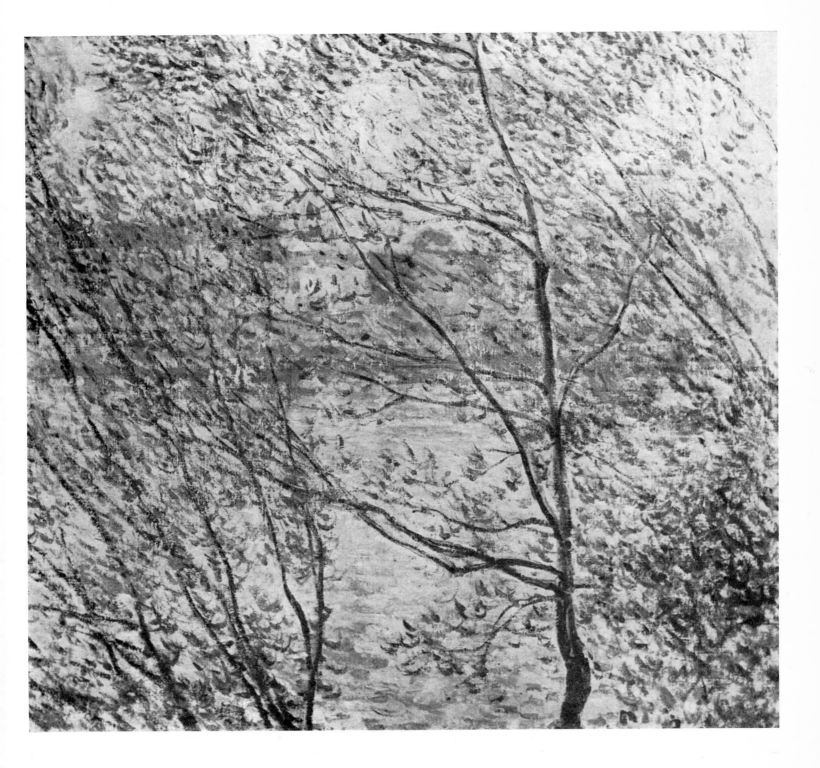

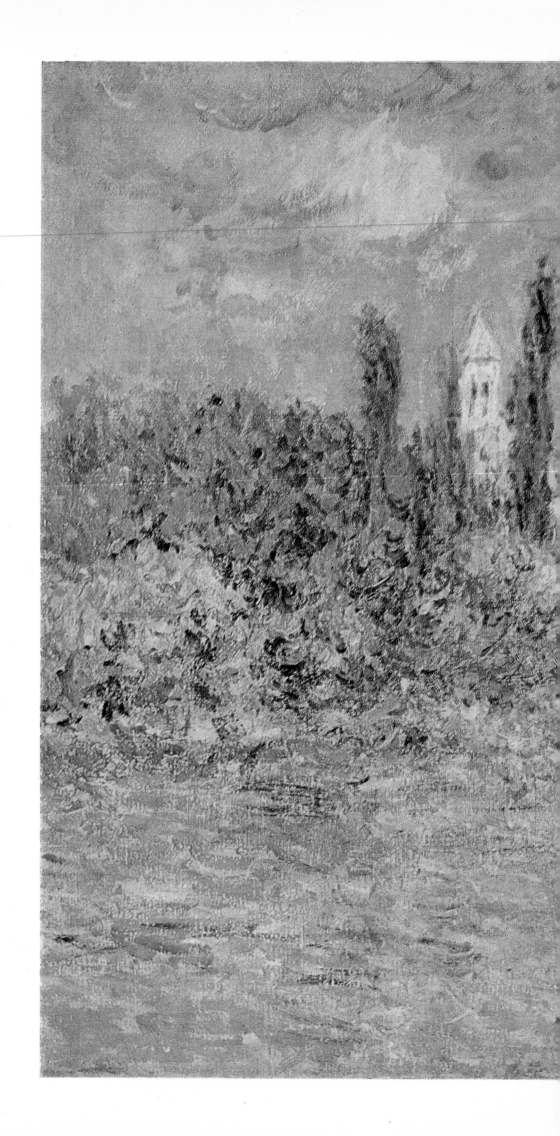

34. Vétheuil

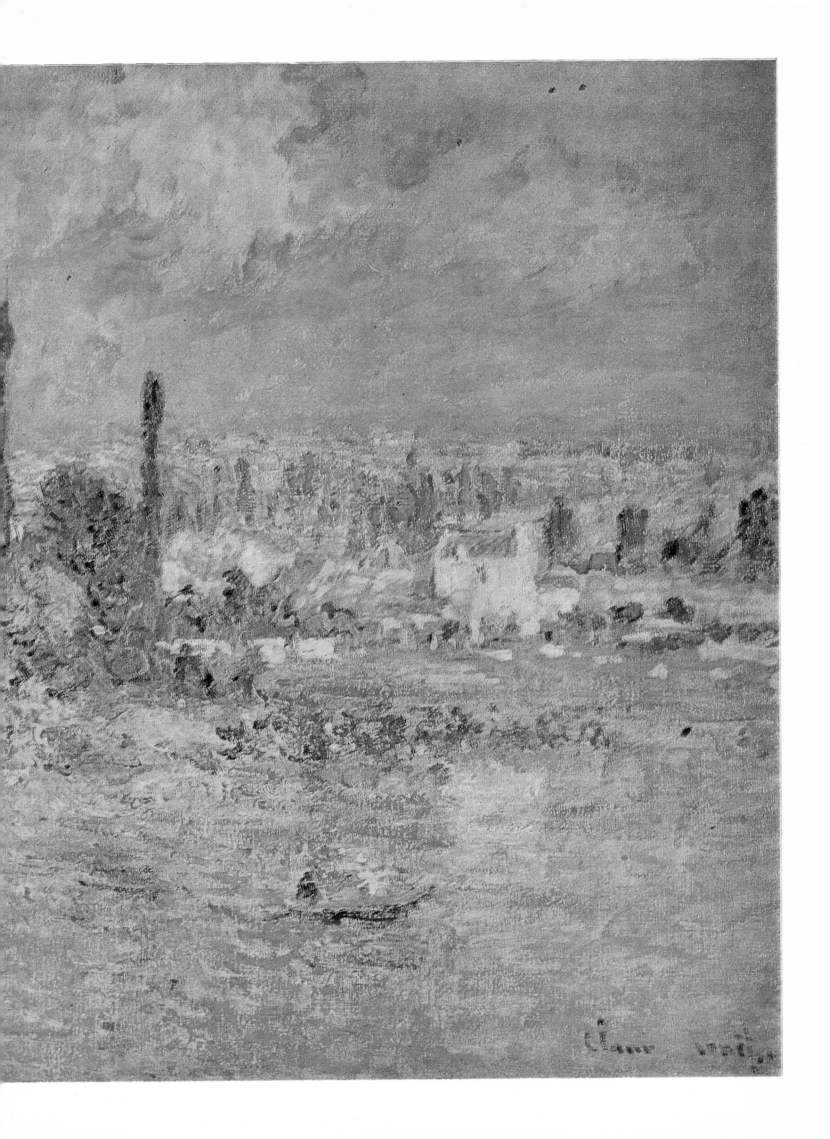

35. The Girdle-cakes

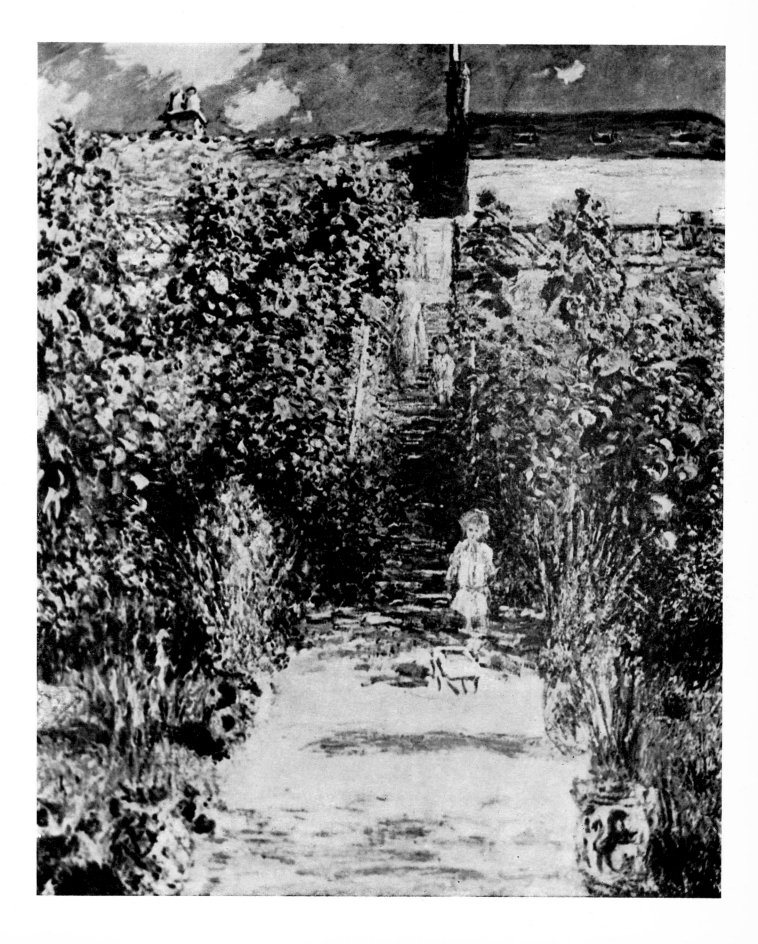

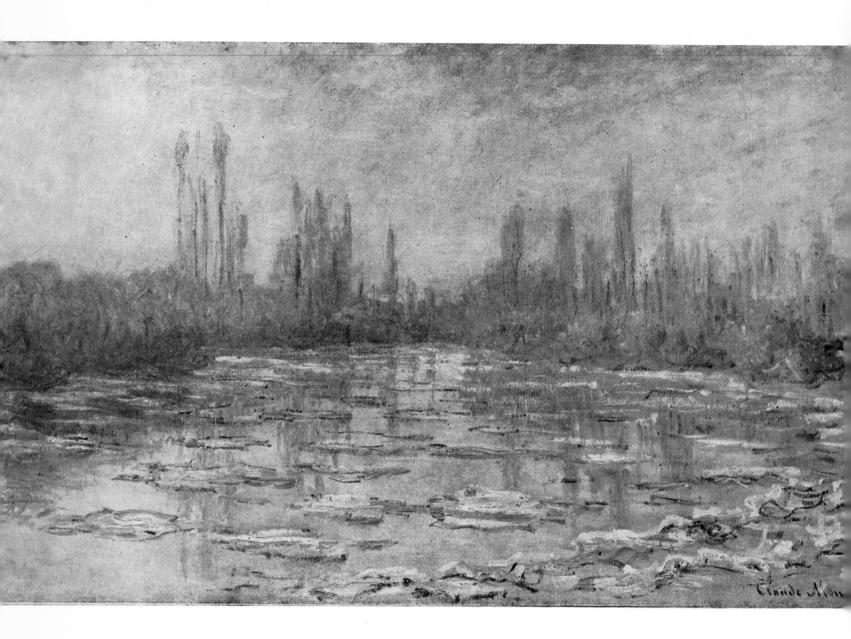

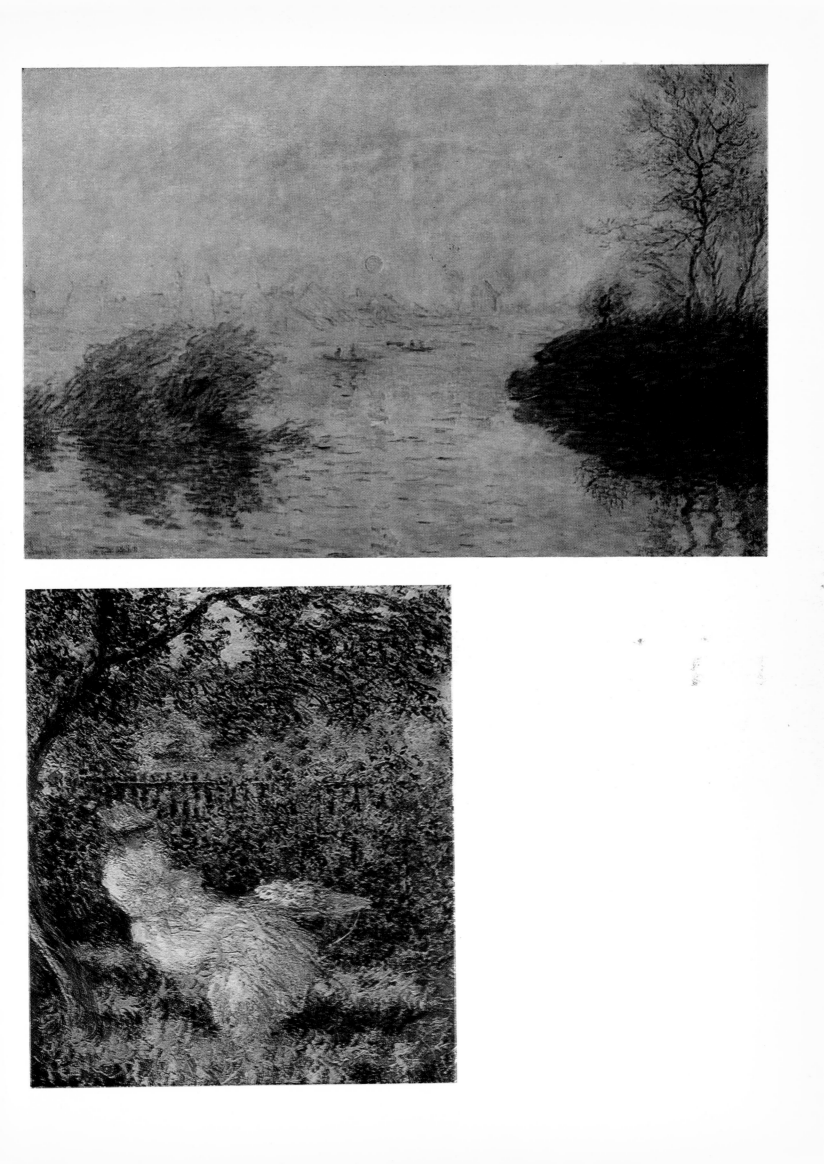

40. Fishermen on the Seine at Poissy

41. The Castle in Dolce Acqua

148

42. Two Haystacks

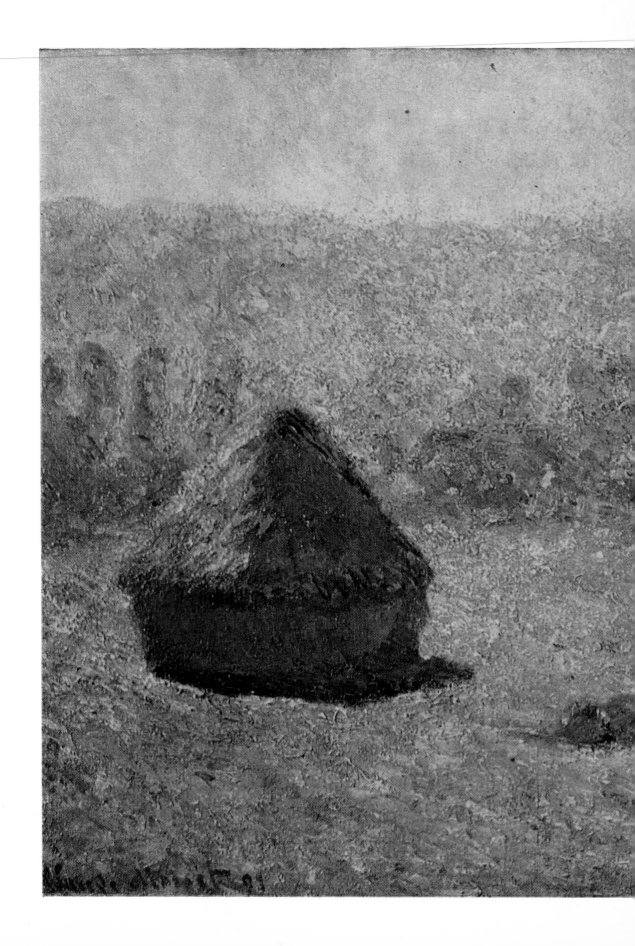

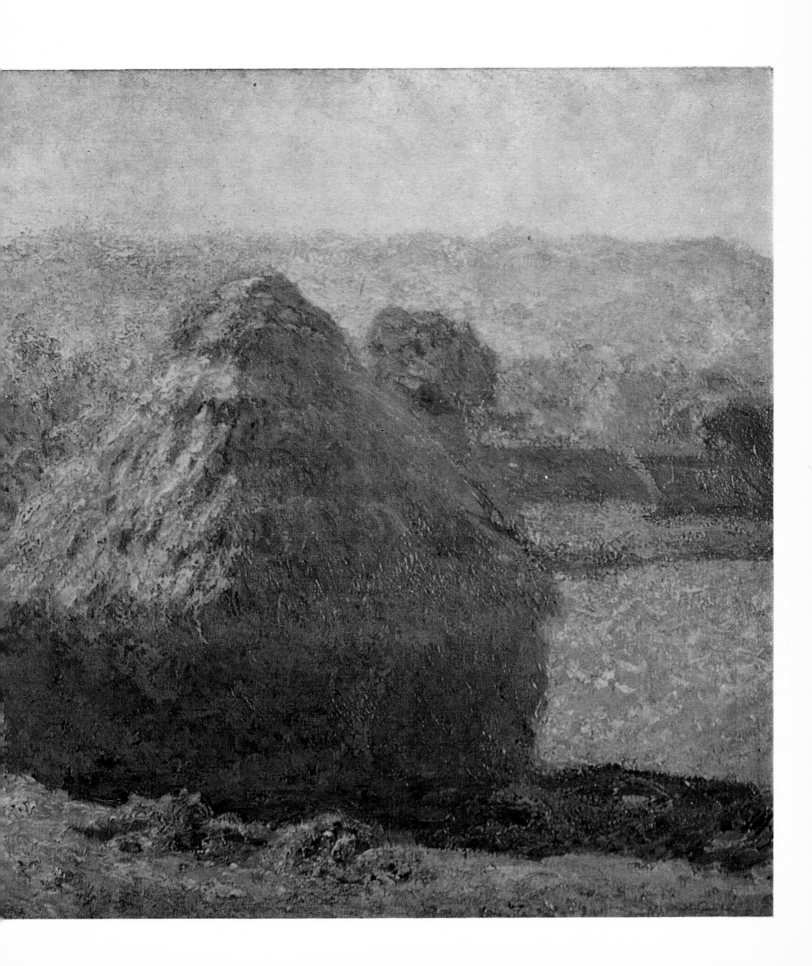

43. Cliffs at Étretat

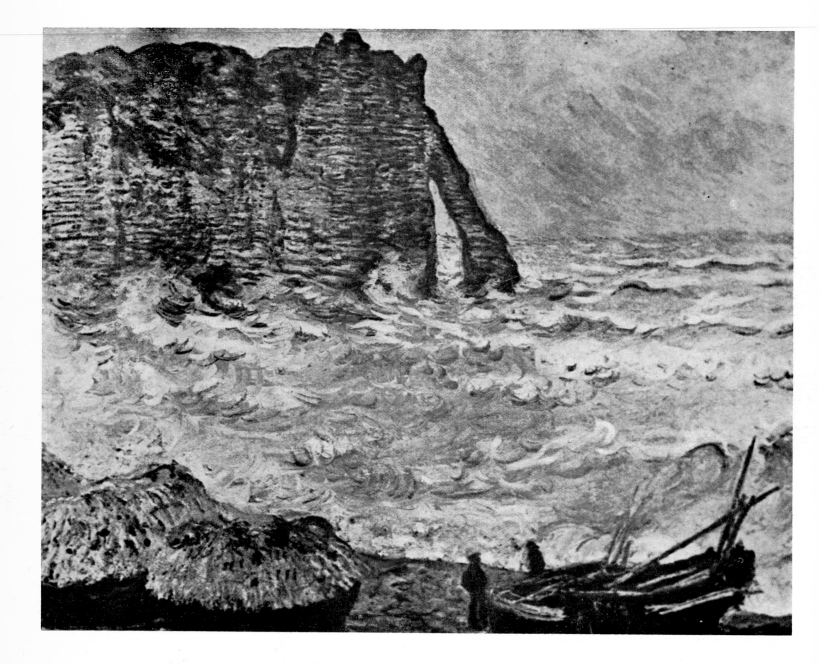

44. Bordighera

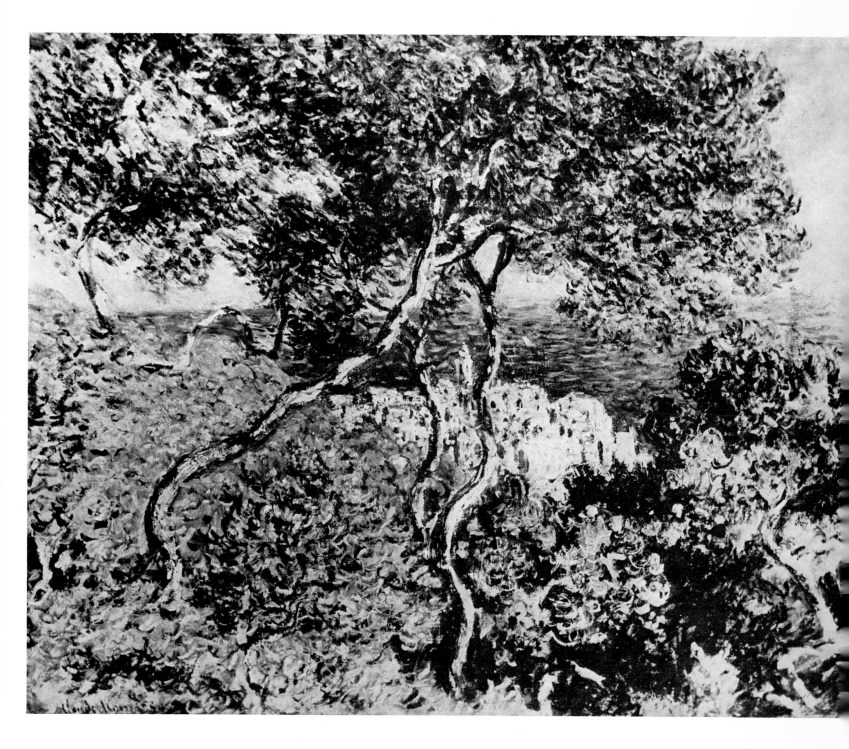

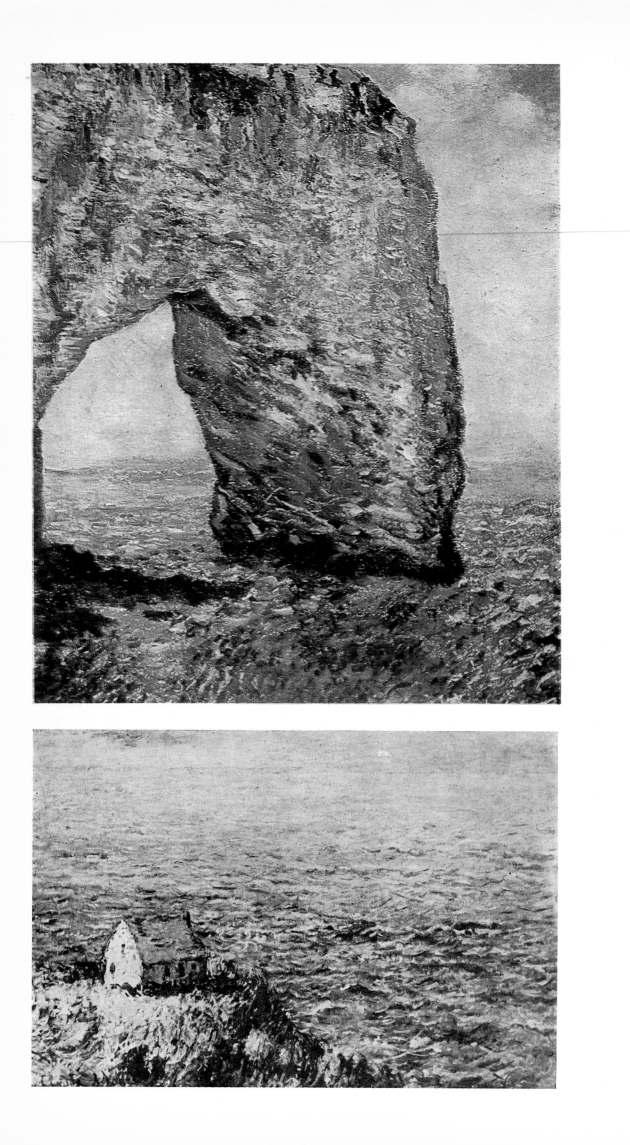

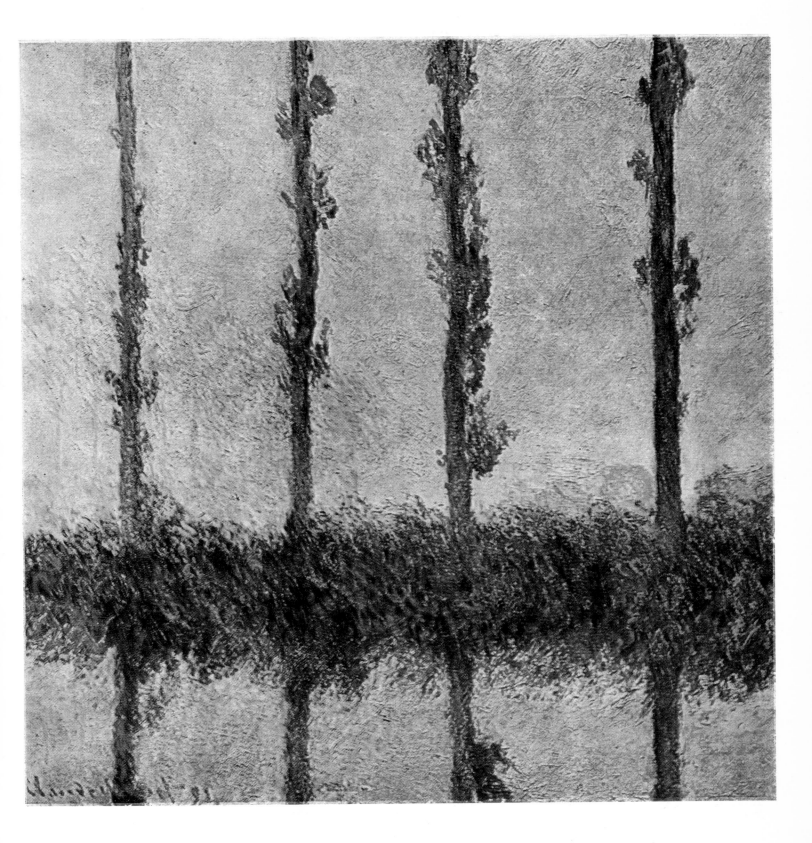

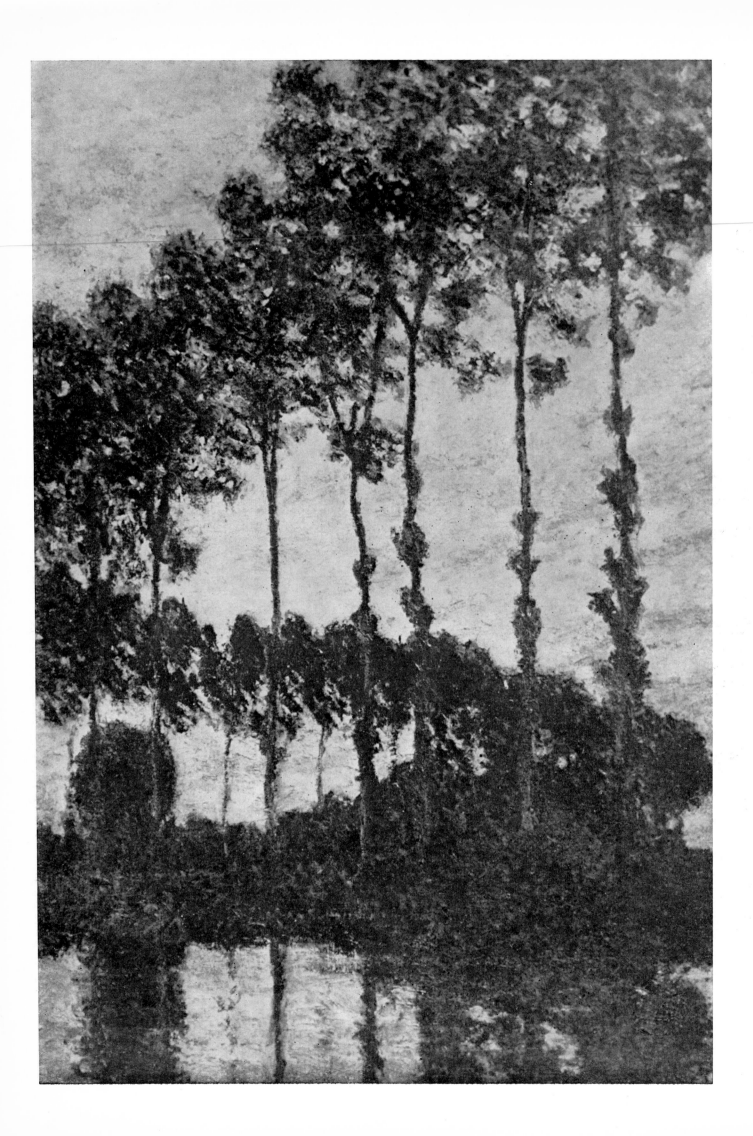

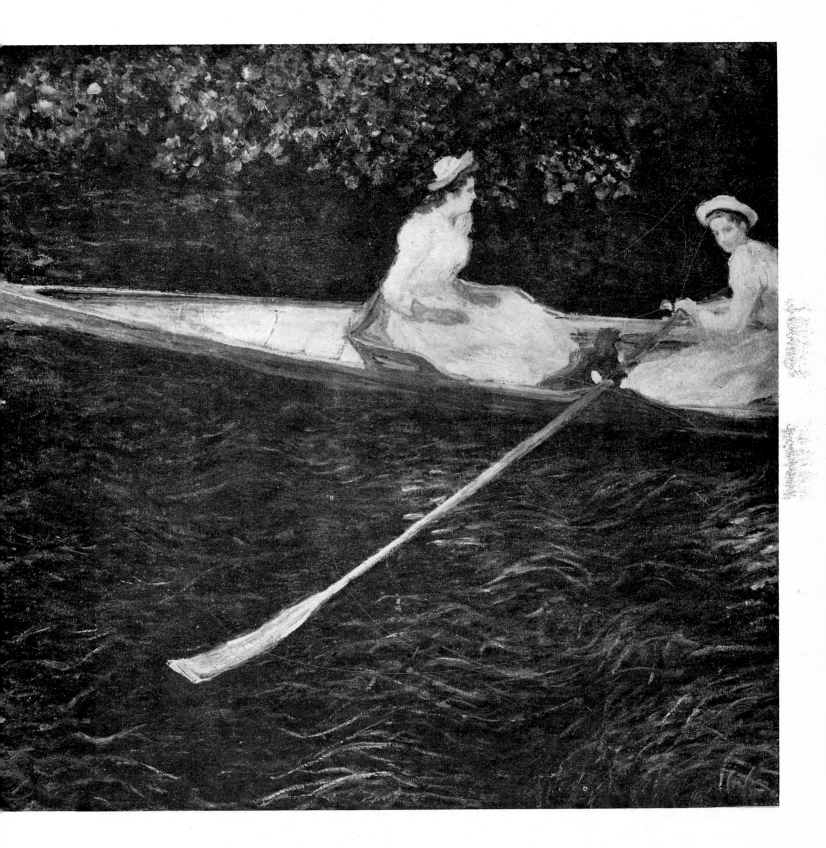

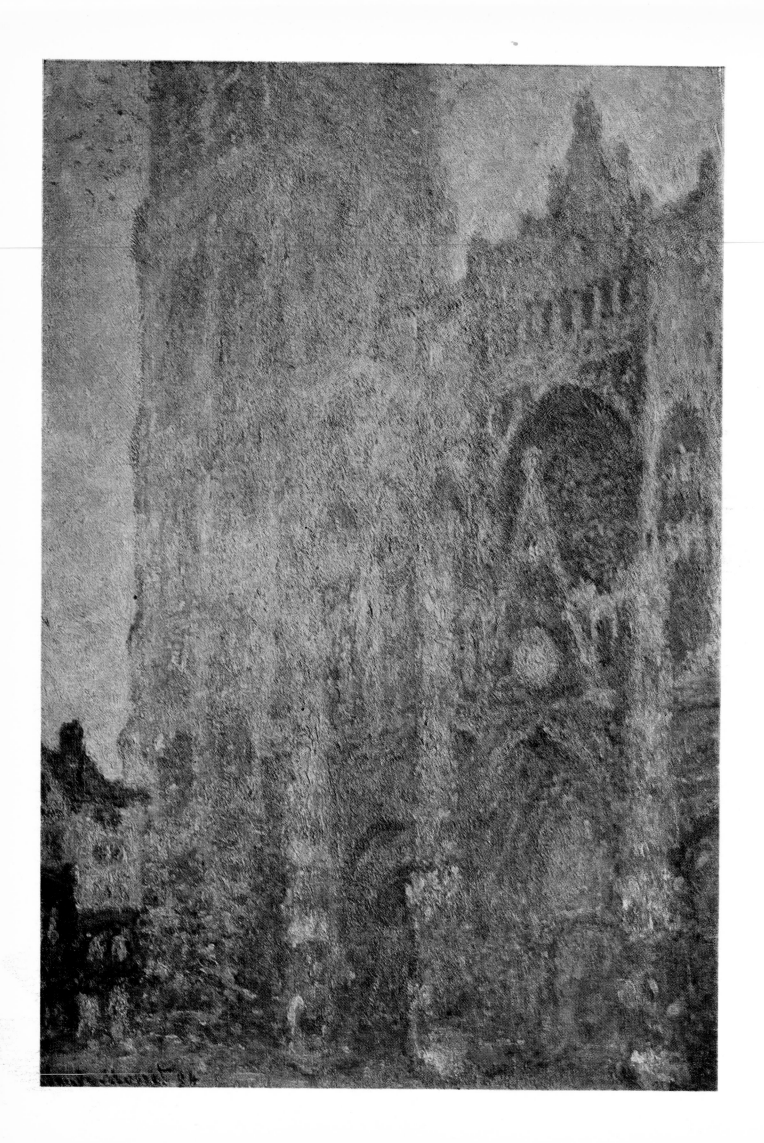

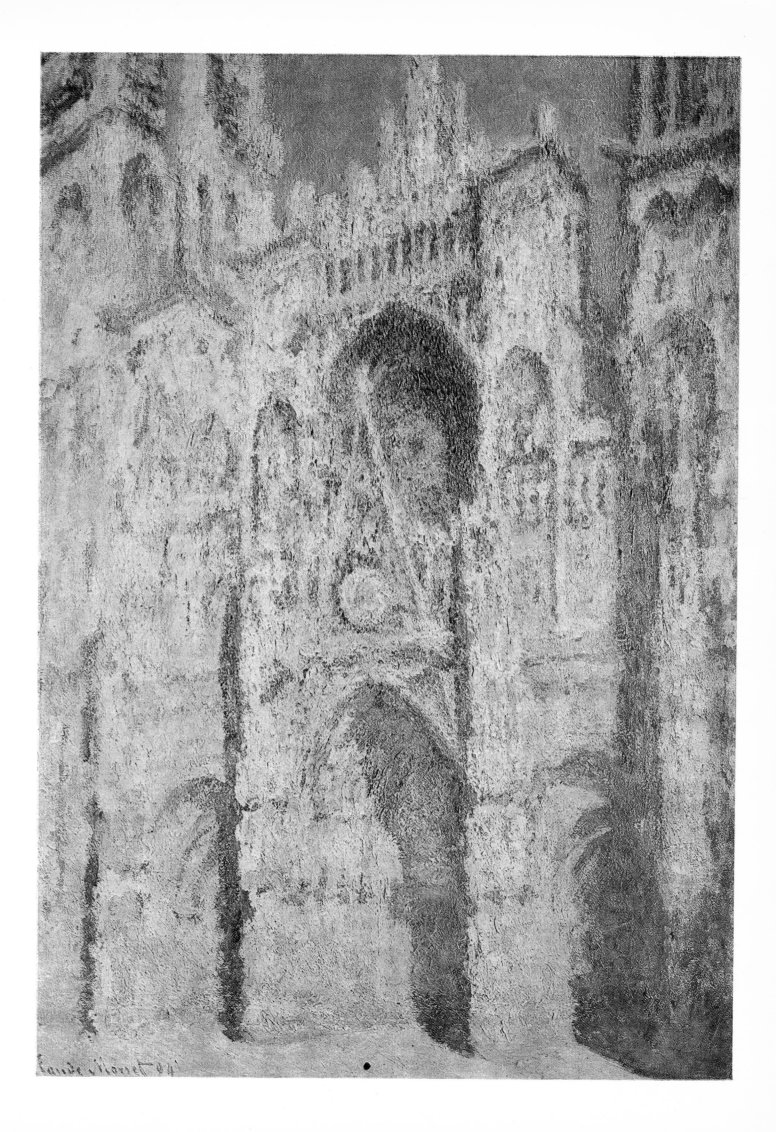

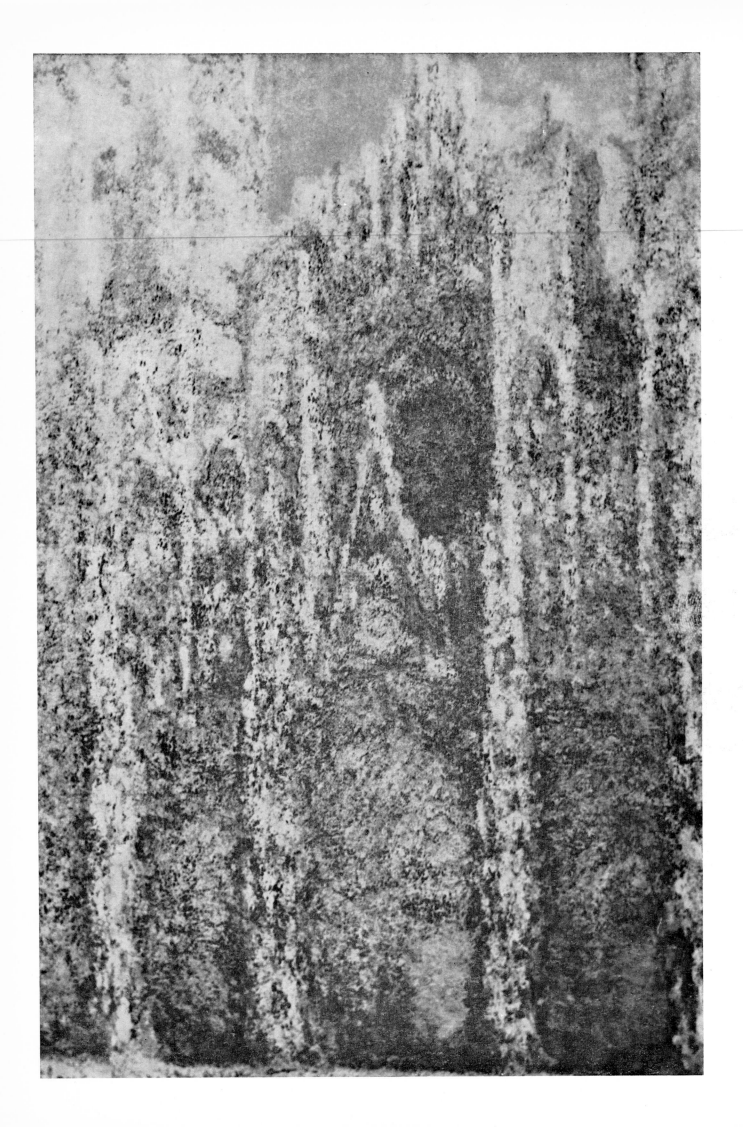

52. The Rouen Cathedral at Sunset.
53. Boats at Argenteuil

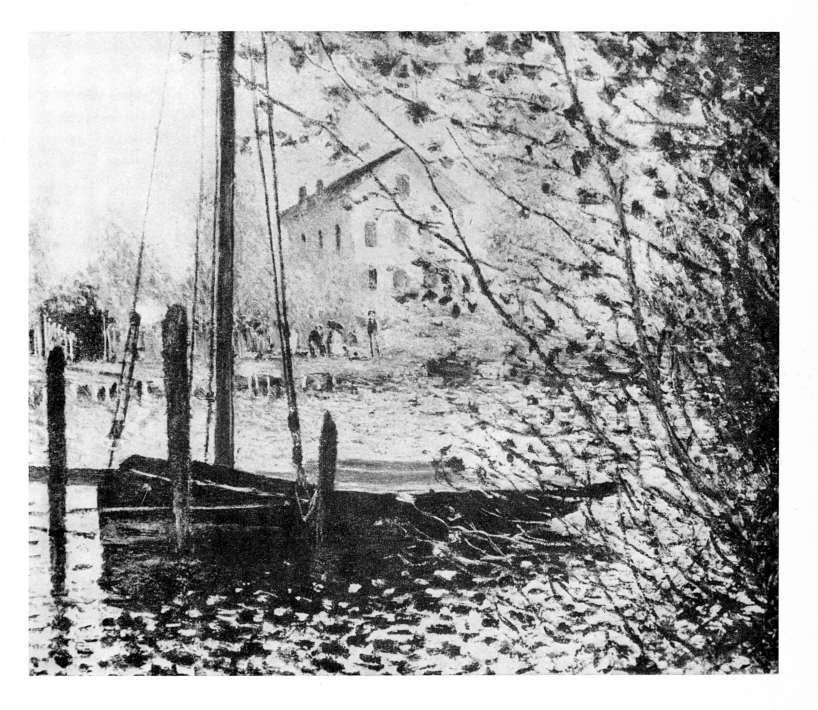

54. The Water lilies. Sunset (detail)
55. The Water lilies

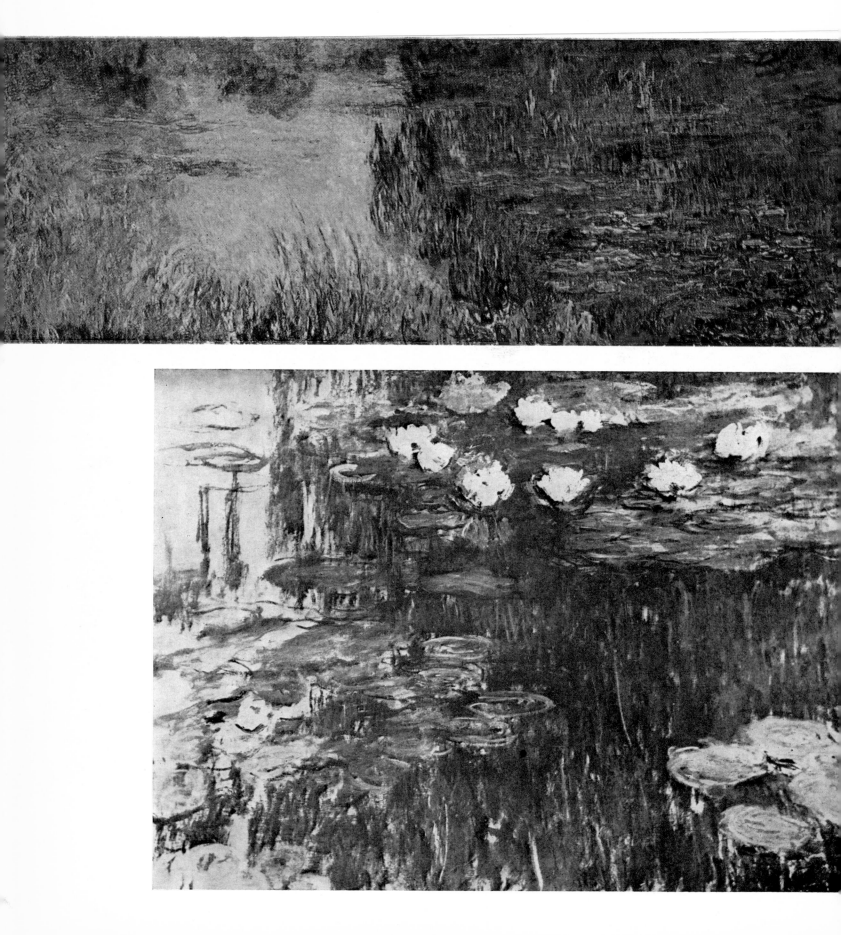

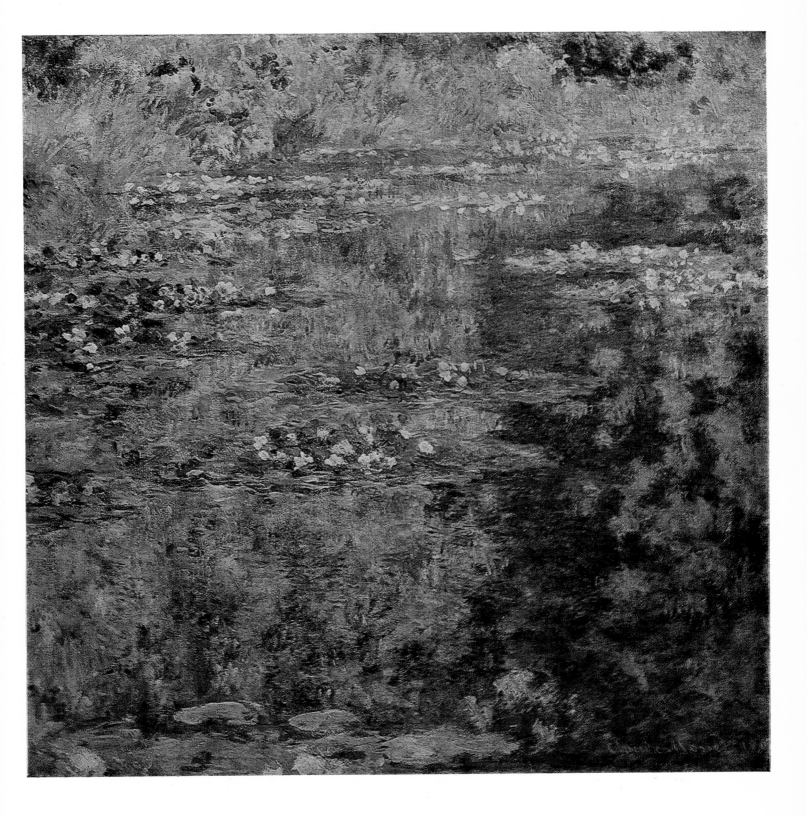

59. Haystacks

60. Rue Montorgueil Decked out with Flags 1878

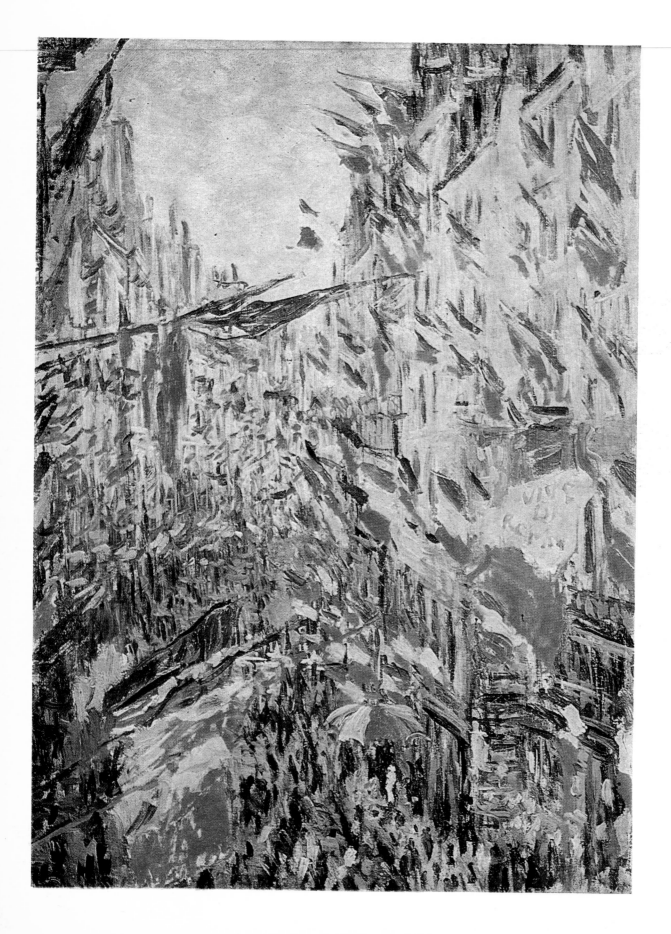

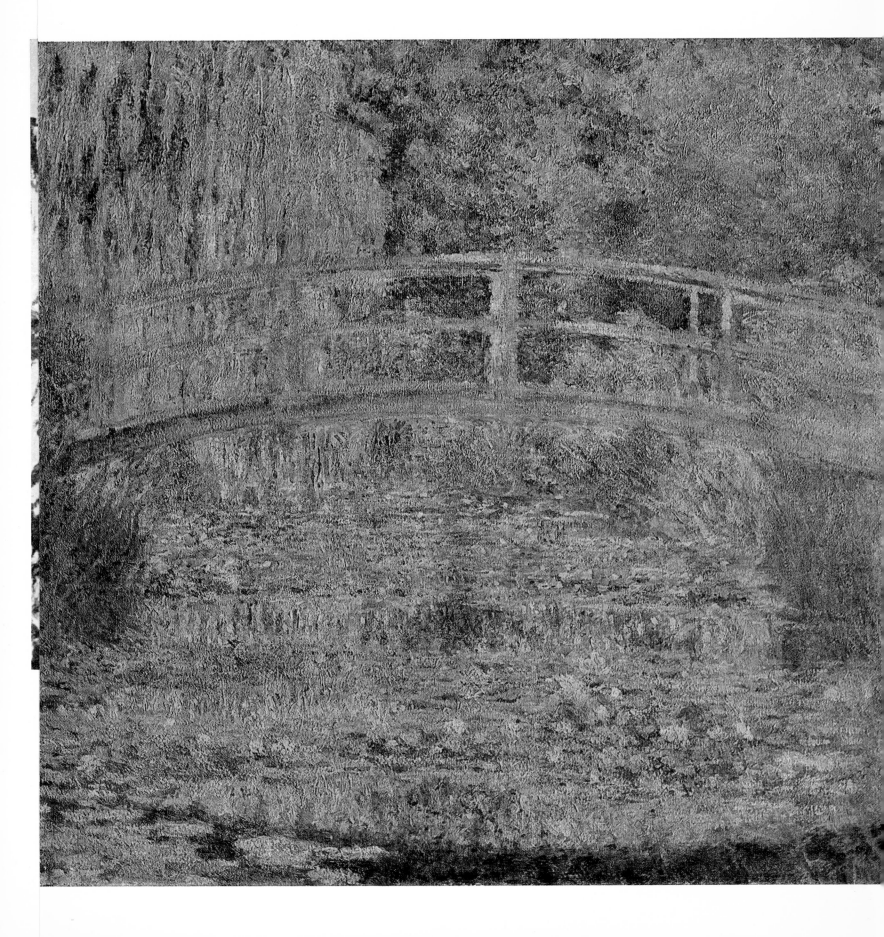

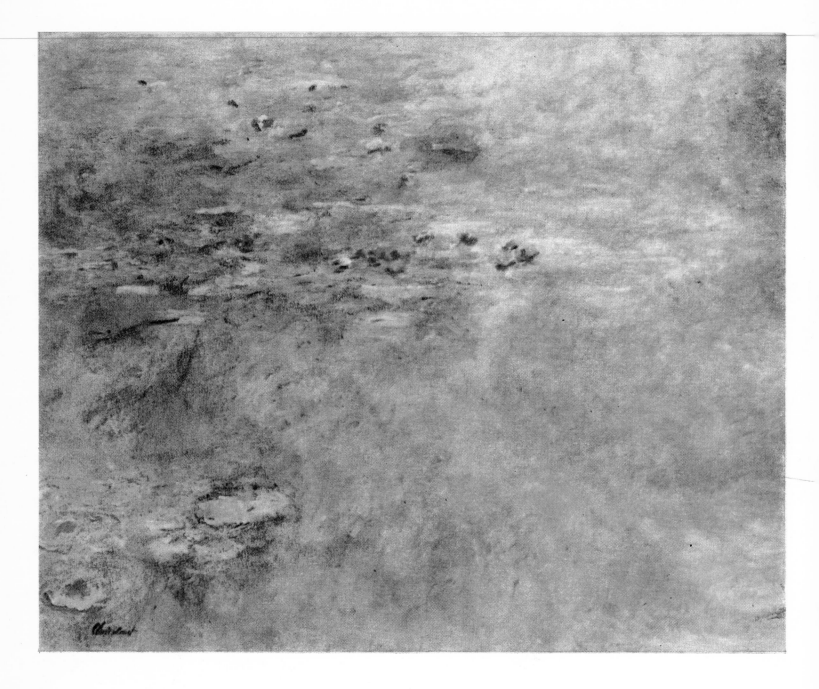

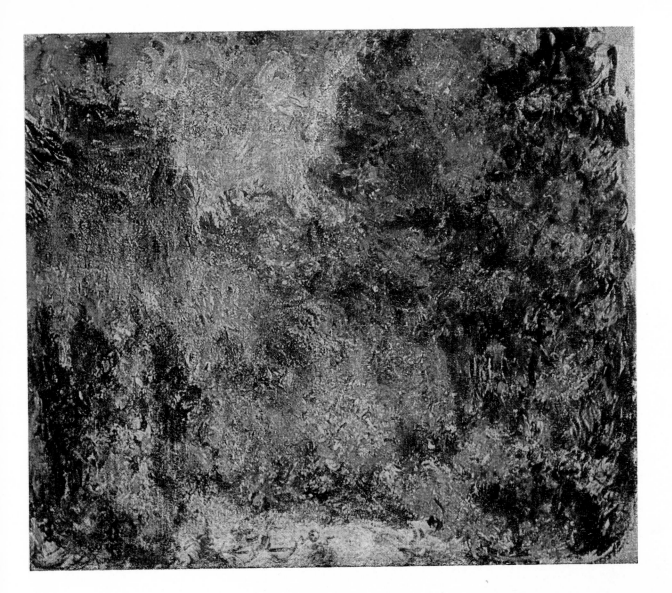

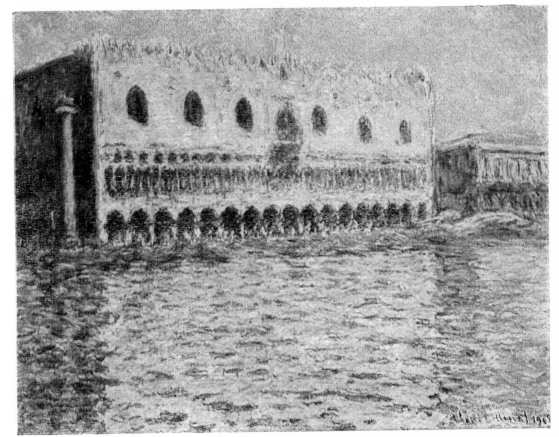

67. Venice, Palazzo da Mula

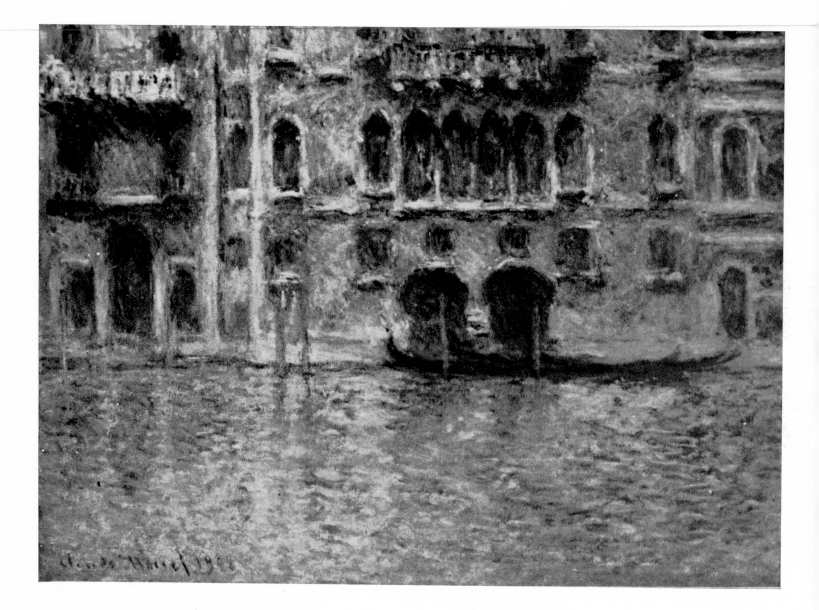

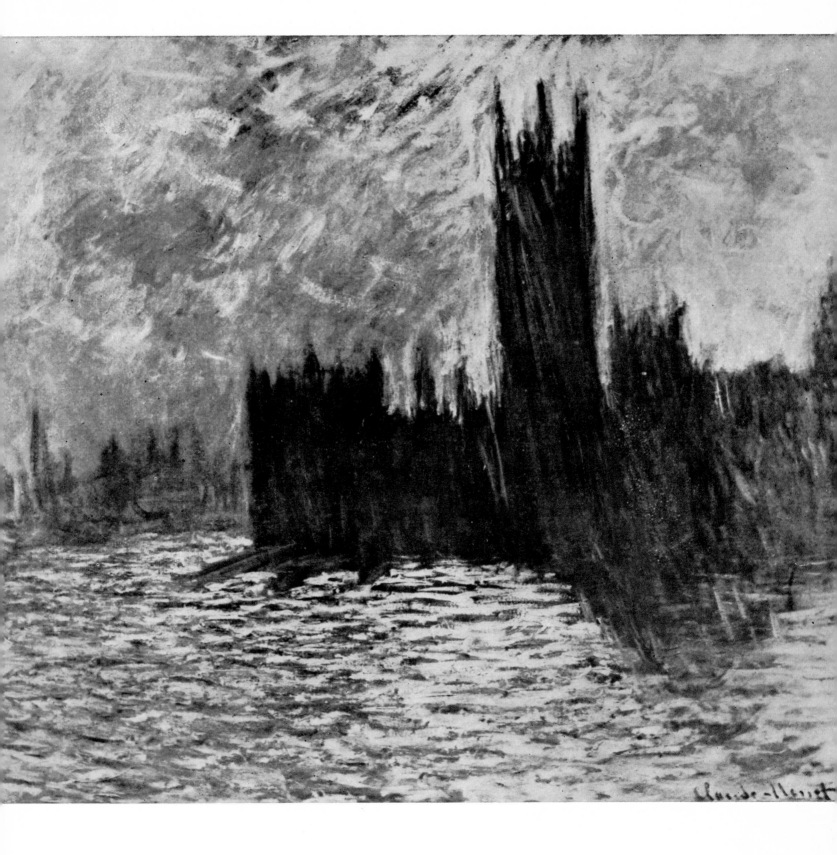

69. The Parliament. Sun Effect through the Mist

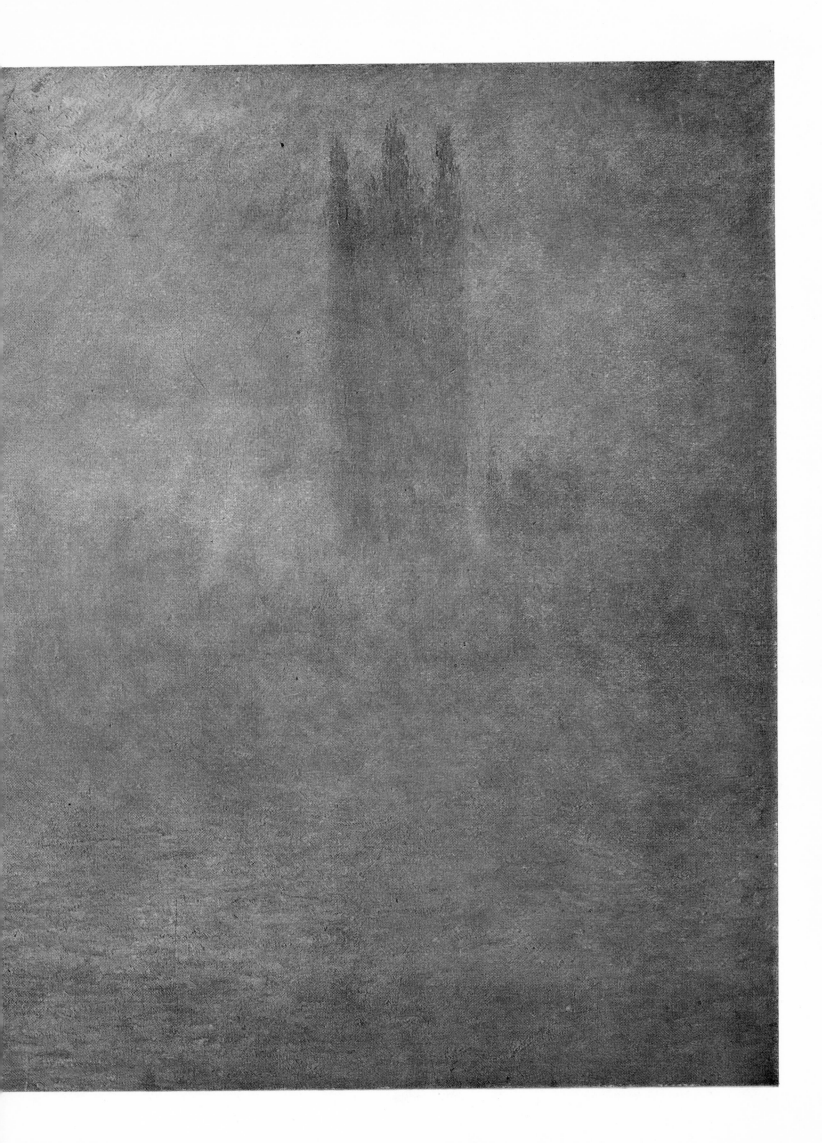

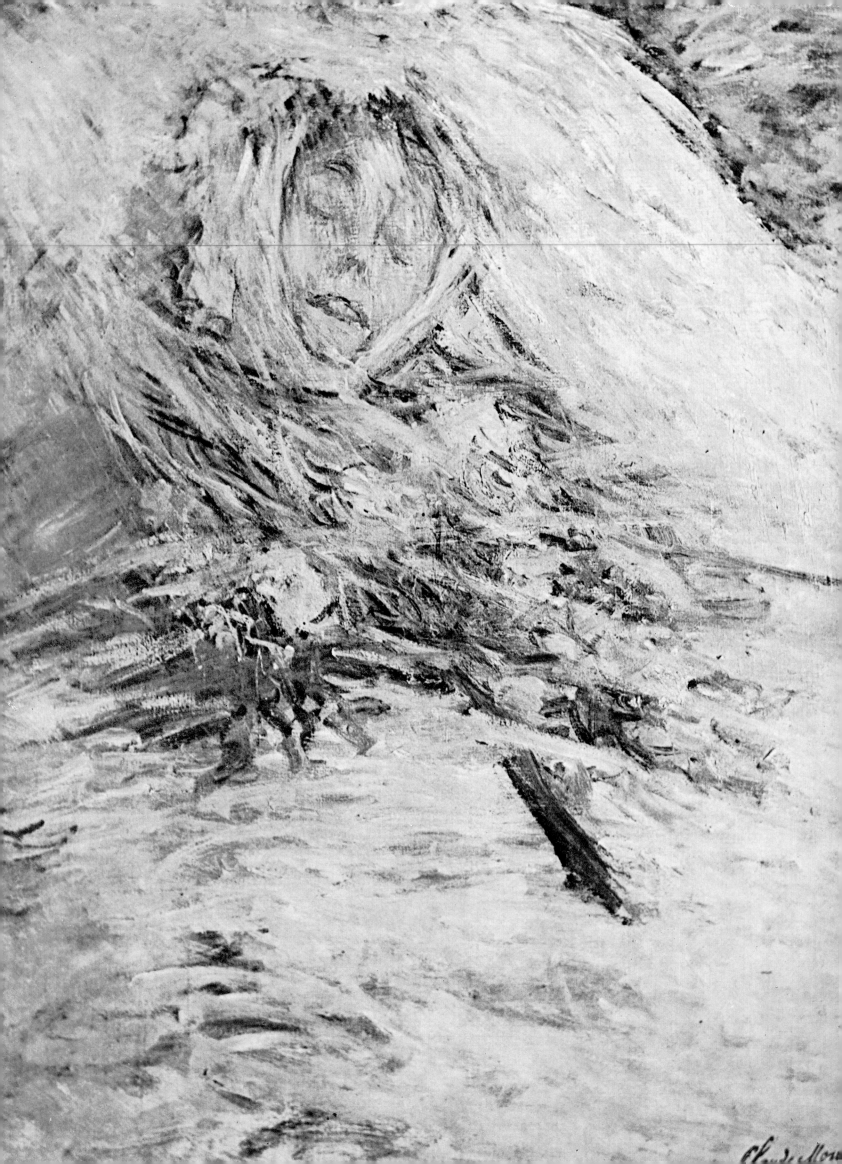

70. Camille Monet on Her Death Bed

MERIDIANE PUBLISHING HOUSE
BUCHAREST

PRINTED IN ROMANIA